First published in 2010 by the

Royal
Botanic Garden
Edinburgh

20A Inverleith Row, Edinburgh EH3 5LR, UK

ISBN: 978-1-906129-33-0

Text © Andrew McDonald Watson

Designed by RBGE
Printed by CCB, Glasgow

Mixed Sources
Product group from well-managed
forests, and other controlled sources
www.fsc.org Cert no. TT-COC-002402
© 1996 Forest Stewardship Council
FSC

Front cover image: Renoir, Pierre Auguste (1841-1919): *The Bay of Naples*, 1881.
New York, Metropolitan Museum of Art. Oil on canvas, 23 1/2 × 32 in. (59.7 × 81.3 cm).
Inscribed: Signed and dated (lower right): Renoir. 81. Bequest of Julia W. Emmons, 1956. (56.135.8 © 2010.)
Image copyright The Metropolitan Museum of Art/Art Resource/Scala, Florence.

Back cover image: Photograph of James Duncan, c. 1900–1905. Image taken from *Mansfield House Magazine*, 1905.
Courtesy of Mansfield College, Oxford.

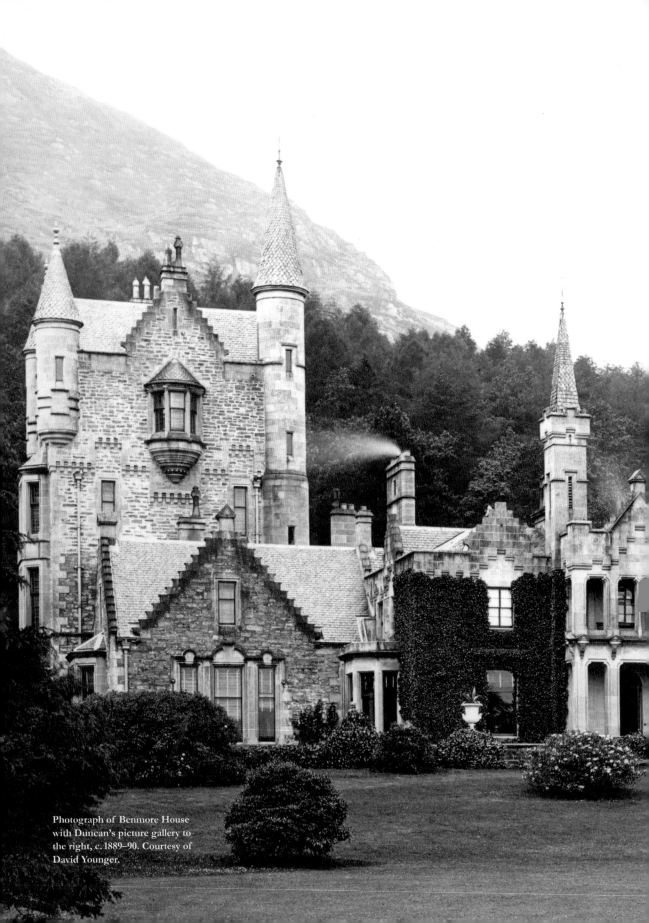

Photograph of Benmore House with Duncan's picture gallery to the right, c. 1889–90. Courtesy of David Younger.

Contents

Acknowledgements

The writing of this book has benefited from the advice, assistance and support of a number of people whom I warmly acknowledge here. My apologies to those I have inadvertently omitted.

I am extremely grateful to the Kerr-Fry Bequest Administering Board, Edinburgh University, for an award to assist with research and reproduction costs. Special thanks also to David Younger, Melina Kennedy, Fiona Marsland and Shirley Page who very kindly allowed documents and photographs from their family archives to be reproduced.

The staff at the following institutions have been extremely helpful: Elaine MacGillivray and staff, Archives and Special Collections, Mitchell Library; Robert Wenley, Barber Institute; Frances Fowle, Helen Smailes and Sarah Jeffcott, National Galleries of Scotland; Godfrey Evans, National Museums Scotland; George Woods, McLean Art Gallery and Museum, Greenock; Jackie Davenport, Argyll and Bute Archives; Eleanor Harris, Argyll and Bute Library; John Stirling, Castle House Museum, Dunoon; Jim MacLean and Archie Fergusson, *Dunoon Observer and Argyllshire Standard*; Alma Jenner, Mansfield College, Oxford; Judy Powles, Spurgeon's College, London; François Coulon, Musée des Beaux-Arts, Rennes; Paul Louis Durand-Ruel and Flavie Durand-Ruel, Durand-Ruel Archives; Christian Fuhrmeister, Zentralinstitut für Kunstgeschichte, Munich; Maureen O'Brien, Museum of Art, Rhode Island School of Design; Holly Frisbee and Cathy Herbert, Philadelphia Museum of Art; Liana Paredes, Hillwood Museum; Aimee Marshall, The Art Institute of Chicago; Fred Ross and Sharon O'Brien at the Art Renewal Center; and Asher Miller, Metropolitan Museum of Art New York, whose correspondence was greatly stimulating and whose help was unfailing during the exciting process of establishing Duncan as the first owner of Renoir's *The Bay of Naples*.

I am extremely grateful to Ronald Pickvance for his advice and generosity in sharing information, and to Lesley O'Donnell, Robert Wenley, George Glen and Linda Whiteley, whose comments on the text greatly improved it. I owe a great debt to Colin J. Bailey, who as advisor and critic was involved with this project from the beginning and contributed to all its aspects.

For their support, encouragement and help with aspects of the research, I thank Nick Adair, Bill Robb, Simon Houfe, Chris and Anne Beales, Alan Butts, Simon Lowe and, most of all, my wife, for her enthusiasm throughout, especially her lateral thinking which often led to the discovery of crucial information.

I thank the staff at RBGE, especially Curator of Benmore Botanic Garden Peter Baxter, Publications Manager Hamish Adamson, Production Editor Alice Jacobs and Designer Caroline Muir with whom it has been a great pleasure to collaborate.

I owe the greatest debt of gratitude to my parents and this book is dedicated to them.

◀ Photograph of James Duncan, c. 1900–1905. Image taken from *Mansfield House Magazine*, 1905. Courtesy of Mansfield College, Oxford.

Foreword

Today, visitors to Benmore Botanic Garden walk through lush green landscapes with towering trees that are a living tribute to more than two centuries of distinguished gardening history. These landscapes, planted with such vision and imagination, are the legacy of a succession of notable people who came to own Benmore. Each chapter in Benmore's occupation enriched the gardens: from Ross Wilson's 1820 plantings of conifers, to the avenue of giant redwoods laid out by Piers Patrick in 1863, the recently resurrected 1870s fernery of James Duncan, the rhododendrons of the Younger family and the most recent plant introductions from Japan. Yet some of the most significant pieces of its history have disappeared without trace from Benmore and their story has remained untold until now.

This important new publication by Andrew Watson brings to life the period between 1870 and 1889 when James Duncan was the Laird of Benmore. It is a fascinating story, skilfully told. Duncan most likely studied chemistry in Glasgow, and built his considerable fortune by developing a revolutionary new method for refining sugar.

Immediately after acquiring Benmore, James Duncan began its transformation with extraordinary energy, planting over six million trees. In addition to the fernery, wedged into a rocky ravine, he built what was in its day the most extensive range of glasshouses in Scotland. But even greater than his passion for plants was his enthusiasm for collecting art and in 1879 his large picture gallery for its display was completed, adjacent to Benmore House. With works by Delacroix, Rubens, Raeburn, Goya and Corot, it opened to the public in 1881 and was described in 1885 as "one of the finest galleries in Europe … filled with choicest works of ancient and modern art". Sugar prices eventually crashed. Neither the picture gallery nor the glasshouses remain today. Duncan's collection of art is now dispersed through galleries across the world. Andrew Watson has succeeded in researching and revealing, for the first time, the life of a distinguished but private subject, one who made an outstanding contribution to society and yet who remained little known. His very readable and enjoyable account of the people James Duncan knew and interacted with provides a fresh new insight into the connections between Cowal and the world.

Great art and botanic gardens may seem unlikely companions but they are not. In 1960, when Harold Fletcher was Regius Keeper, he offered Inverleith House at the Edinburgh Garden as the first home of Scotland's Gallery of Modern Art. Inverleith House has continued to deliver an internationally acclaimed arts programme since the Gallery of Modern Art moved to its permanent home in 1984. I think that James Duncan would have approved.

Stephen Blackmore FRSE
Regius Keeper
Royal Botanic Garden Edinburgh

▲ Professor Stephen Blackmore FRSE, Reguis Keeper, Royal Botanic Garden Edinburgh.
Photo: RBGE/Lynsey Wilson.

◀ The Pond at Benmore Botanic Garden.
Photo: RBGE/Lynsey Wilson.

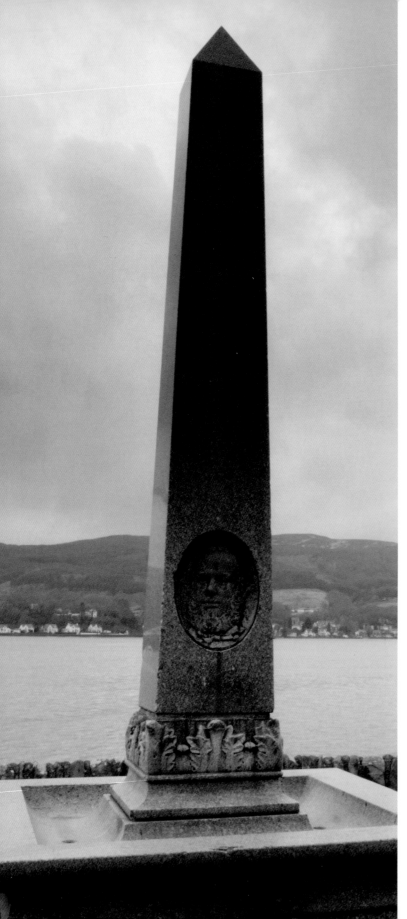

Introduction

In the early 1850s a brilliant young student of chemistry from Glasgow took a boat trip from Greenock to the lochs and coastlines of Argyllshire. While on Loch Long, he conceived a unique method of refining sugar. By 1880 James Duncan (1834–1905) was acknowledged as the foremost technical expert and innovator of his generation in sugar refining.

Patenting his idea in Greenock, where he worked between 1858 and 1861, he then moved south and developed a factory in Silvertown, the largest and most profitable in London. In 1878 he was elected fellow of the Society of Chemical Industry, later becoming its Vice President. By 1879 he held the prestigious post of Chairman of the Sugar Refiners' Committee, and also became Vice President of the Railway and Canal Traders' Union. His important charitable work was widely known throughout Britain: he gave 20 per cent of his annual £100,000 salary to a range of causes, making him one of the most committed philanthropists of the time. Universally recognised as a major collector of fine art, in 1878 Duncan was elected Vice President of the Royal Glasgow Institute of Fine Arts and was acknowledged as a generous lender of pictures to its annual exhibitions. He regularly contributed works to European exhibitions, including the most prestigious at the Paris Salon,

and to key international exhibitions of art and industry in France and Germany in the 1870s and 1880s.

Duncan's close acquaintances included figures distinguished in a number of fields: the chemist James "Paraffin" Young, who established the world's first commercial oil works; the pioneering ophthalmic surgeon Dr Neven Gordon Cluckie, whose work led to the establishment of eye surgeries in hospitals throughout Britain; the celebrated preacher Charles Spurgeon; Rev. Henry Boyd (Principal of Hertford College Oxford, 1878–1922), with whom Duncan had worked closely in the 1870s to improve working conditions in London's East End; and Gustave Doré, the French artist whose gallery, paintings and book illustrations proved so popular in Britain. Duncan had contact with the eminent botanist Sir Joseph Dalton Hooker and with Henry Morton Stanley, the explorer and friend of David Livingstone who visited Duncan some time in the 1870s or 1880s. Duncan was also one of the most valued and important clients of the influential French picture dealer Paul Durand-Ruel, and regularly frequented the studios of Europe's most famous painters.

This book tells the story of Duncan's fascinating life for the first time. It considers his upbringing in Glasgow and assesses his prodigious talent in commerce, first in Greenock and afterwards in London. Central to his story is the period from 1870 to 1885 when, as Laird of Benmore, he undertook major arboricultural and agricultural projects and constructed a picture gallery that was one of the most magnificent to be built in late 19th-century Europe. The reminiscences of the many visitors to Benmore provide evidence of the importance of Duncan's picture gallery and his relations with European painters and dealers, and allow insights into his personality, taste and international reputation.

Yet Duncan's outstanding achievements have been largely overlooked, and this has made the task of reconstructing his life more difficult. This is partly to do with the fact that, despite his prominence as a leading industrialist, philanthropist and art collector, he was an extremely private individual who shunned publicity in many of his spheres of activity. When he gave vast amounts of his personal fortune to charitable causes, this was always done anonymously; when he secured one of the most expensive and sought after pictures by Landseer in 1877, it was through an intermediary. He left no heirs, no possessions or papers and no autograph letters. Contemporary accounts of him are rare. His art collection, which contained some of Europe's greatest masterpieces, is never mentioned in the leading British art journals of the period; and despite having been a regular contributor to *The Times* on the sugar trade, it did not feature an obituary. What is intriguing is how such a major figure, so eminent in his lifetime, could fall into the shadows of late Victorian Britain, to be largely forgotten ever since.

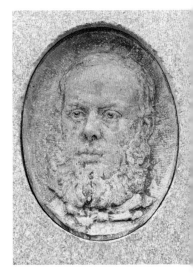

▲ Archibald Macfarlane Shannan, oval bronze bas relief of Duncan. Photo: Peter Clarke.

◀ Granite obelisk memorial to James Duncan with oval bronze bas relief of James Duncan by Archibald Macfarlane Shannan. Holy Loch, Kilmun, Argyllshire. Photo: Peter Clarke.

▲ John Knox,
Old Glasgow Bridge, c. 1817.
Oil on canvas, 30.5 × 119.5 cm.
Culture and Sport Glasgow
(Museums) (OG.1955.119).

Early Years

Duncan was born on 4 April 1834
in Old Mosesfield House, an 18th-
century villa on the crown of Balgrayhill
in the rural setting of Springburn,
north east of Glasgow. This idyllic
site afforded spectacular views over
the city towards the Argyllshire hills.

By the early 19th century Springburn
was a desirable area, and a number of
Glasgow merchants built villas there
among the existing 18th-century cottages.
In 1824 Duncan's father, James Duncan
II, a successful bookseller, had moved
into Old Mosesfield House, originally
called Old Broomfield, once the home
of William Moses, who had made his
fortune hiring sedan chairs. Five years
later, in 1829, James Duncan II married
Mary Dalglish, daughter of the merchant
Robert Dalglish, who lived nearby at
Balgray Cottage. The couple spent the

first nine years of their marriage in
Old Mosesfield.

James Duncan II's family was well
established in Glasgow's book trade.
About his own father, James Duncan I,
also a bookseller, we are poorly
informed, but it is known that by 1789
his business in Glasgow's Saltmarket,
where he had operated since 1769,
was on a sound financial footing,
laying the foundation for the future
success of his sons and grandsons.

James Duncan I benefited from
Glasgow's growing economic prosperity.
The 1740s were the so-called Golden
Age for the tobacco trade, on which
much of the city's wealth was founded.
Later in the century the cotton
textile industry broadened Glasgow's
manufacturing base, alongside an
emergent banking system. Between

1740 and 1801 the population of the city rose from 23,000 to 77,000. The book trade also flourished in this period and eight printing houses were established. By the 1760s the two leading publishing houses in Glasgow were those owned by Robert and Andrew Foulis, and by Robert Urie. The Foulis brothers were printers to Glasgow University, specialising in classical works. Urie produced translations of Voltaire and a Greek New Testament. In the period following the deaths of Foulis and Urie in the 1770s, booksellers assumed a more active role in the city, taking advantage of improvements in communications and the ease with which books from London and Edinburgh could now be imported.

In 1781 James Duncan I married Clementina Stirling. It is not certain where they first lived, but in 1794 they acquired various plots of land in the parish of Calder in Lanarkshire and by 1810 they already owned 20 acres in Balgray, Springburn. Of their three sons — Walter, James and George — we know most about Walter and James. Walter went on to run his own stationery business, retiring to Bute in Rothesay by 1851. James Duncan II took over the family's business in the Saltmarket, where he worked until he retired.

▼ A view of Glasgow's Saltmarket taken from *Sketch of the History of Glasgow*, by James Pagan, Glasgow, 1847. Image courtesy of Glasgow City Libraries.

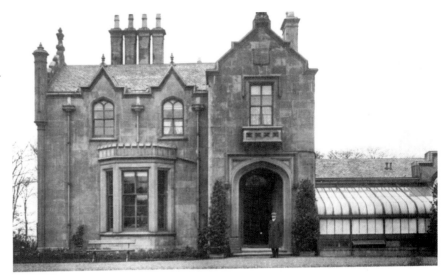

James Duncan II became a central figure in the book trade, selling works ranging from children's books to special editions of Burns's poetry. He knew the prominent Glasgow antiquary Gabriel Neil and William Motherwell, poet, antiquary, journalist and staunch Tory who, towards the end of his short life, edited the *Paisley Advertiser* and the *Glasgow Courier*, the latter a Tory newspaper espousing Orangeism, an Irish variant of traditional Scottish Presbyterianism. It is not certain whether Duncan had strong religious views, but he was a man of conscience and a member of the Glasgow Emancipation Society, an anti-slavery group established in 1833 by William Smeal, a Quaker and Gallowgate tea merchant.

In 1833 James Duncan II, already retired from business, was described as a "highly respectable gentleman" in *Tait's Edinburgh Magazine*, which published a fascinating account of the part Duncan had played in 1821 in exposing a Glasgow weaver, Alexander Richmond, as an alleged government spy and agent provocateur in the Scottish General Rising of April 1820.

There is no evidence as to whether James Duncan II had any interest in the fine arts, but in 1818, amid a growing

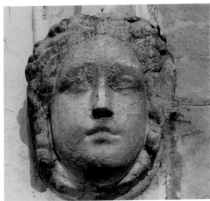

sense of history and national pride in Scotland, he and Motherwell initiated a campaign to have a monument built in honour of "the national champion" William Wallace in "an ardent wish to repair so glaring a neglect". Duncan, as one of the first benefactors, sat on the committee formed to raise funds for the project, which included among its members the Duke of Hamilton. In a letter to an unnamed nobleman, Duncan wrote that it was impossible for him to "express how much it rejoiced" him to hear of the munificent gift which his "Lordship" intended to "bestow towards a colourful statue of that hero". In 1819 we find Duncan in contact with the Edinburgh-born architect Alexander Ramsay, who wrote to him on 6 March to say that he had sent him a "sketch of what we were talking of". Discussions followed between the two men regarding the type of stone to be used and further sketches of the design. For reasons unknown, the project was never realised, but it reveals Duncan's central place in Glasgow society and his willingness to engage with architectural projects.

Duncan was therefore well acquainted with the achievements of David Hamilton, regarded as one of Scotland's most eminent architects. It was Hamilton's mock-Tudor style that Moses McCulloch had copied when designing Balgray Tower (1820), a villa near Duncan's home in Springburn. It is a measure of Duncan's success that in 1838, when Hamilton's reputation was at its height, he commissioned Hamilton himself to build New Mosesfield House.

This characteristic two-storey mock-Tudor villa was designed by Hamilton to face north towards the Argyllshire hills. For his house James Duncan II called on the services of William Mossman I, Glasgow's leading architectural and monumental sculptor. Mossman (who had set up his own business in 1833, with premises at 172 West Nile Street) carved details on several of David Hamilton's buildings, including the lion masks on St Paul's Church, John Street (1836, dem. 1906). The sculptor noted in his Job Book for August 1838 that he had "cut for Mr Duncan of Mosesfield two faces upon the door of his new house" at a cost of two guineas.

James Duncan II's young family enjoyed a cultivated, literary life in their new home, although their stay in New Mosesfield was very short lived. James Duncan II died in 1840, leaving his widow with five young children. James, the third of their children, was just six years old.

By 1851 Mary was residing at 9 Ann Street, Edinburgh, in which year the census listed her son James as "scholar" at an unnamed school. Wherever he was educated, James certainly learned French, and most probably German, languages that eventually served him well in business and perhaps also in his activities as a collector on the international scene. He must have been predisposed towards the sciences, as his expertise in chemistry was to determine the course of his working life.

Soon after leaving school James chose the sugar trade as his profession. Accordingly, he moved west to Greenock, the heart of Scotland's sugar trade, where he embarked on his remarkable career.

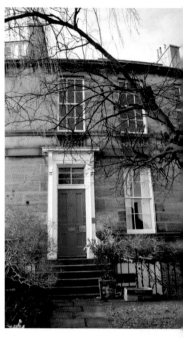

▲ Duncan's childhood home in Ann Street, Edinburgh. Photo: RBGE/ Hamish Adamson.

▲ *A View of Greenock*, 1891.
Colour lithograph print.
© McLean Museum and
Art Gallery/Inverclyde Council
(WL5005).

Greenock and London: 1850–1870

The Prince of Sugar Refiners

Duncan entered a business world whose atmosphere was very different from the one his father had experienced. From 1800 onwards steam technology had profoundly affected most types of manufacturing. By the 1850s Duncan's native Springburn had changed from a rural village into a major centre for the production of locomotives. Ninety per cent of British pig iron exports came from Glasgow. In the sugar industry, Greenock was by now the largest depot for raw material in Britain, and second only to London as a manufacturing base.

Contemporary accounts maintain that Duncan entered the sugar trade aged 11 and built his fortune on very humble beginnings. Yet in the 1851 census Duncan was listed still as a "scholar at school"; moreover, in addition to monies left him by his father, in 1846 he had inherited land and properties from his uncle, George Duncan. He was thus almost certainly in his late teens when he entered the office of Messrs Warden, Macpherson and Co., a well-known sugar broking firm based probably in Glasgow. According to the shipping

journal *Fairplay*, "dividing his time between the office, the warehouse, and the works", Duncan's "retentive mind" enabled him quickly to assimilate information about both the firm and the trade. The same journal records that during this time Duncan studied chemistry, his aptitude for which helped him become the most innovative refiner of his generation.

In 1858, at the age of 24 and conscious of the increasing rise in sugar consumption in Britain at this time, Duncan started work as a refiner, taking premises at 12 Eldon Street, Greenock, where he lived with his brother George. He went into partnership with Alexander Scott, and together they developed a highly successful company, distinguishing themselves in their manufacture of sugar through their pioneering use of centrifugal machines. These filtered the syrup to produce yellow sugars. Duncan devised a new method of boiling these sugars at a very low temperature, whereby they retained more syrup in their granular structure than had previously been achieved by other refiners. The result was a finer product that sold at a much higher price than the sugar produced by Duncan and Scott's competitors. As a consequence, they rapidly accumulated vast capital. Their process was recognised at the time as "entirely unique" and thereafter practised only in British refineries, giving them enormous advantage in the global market. When, soon afterwards, James Bell joined the firm, the company became Bell, Duncan and Scott, with premises at Baker Street, one of the largest in Greenock.

▼ Woodcut from the late 19th century by Émile Bourdelin entitled 'Vue Interiéure d'une Sucrerie Centrale installée par la Cie de Fives-Lille' ('Interior view of a central sugar refinery installed by the company Fives-Lille'). The large interior is filled with machinery and vats used for refining sugar. Workers tend to the machines on the balconies and at ground level. Image: © Science Museum/ SSPL.

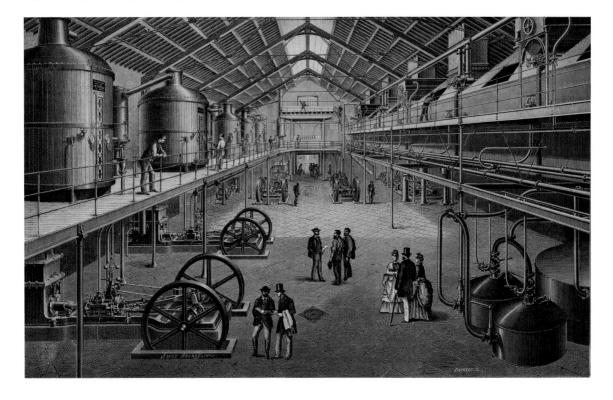

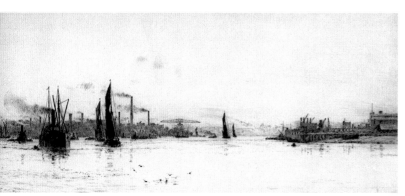

▲ William Lionel Wyllie, *Woolwich Reach*, c. 1890. Etching. View from the Thames showing Silvertown and docks. © National Maritime Museum, Greenwich, London (PW2192).

Bell, Duncan and Scott flourished to such an extent that they were able to open a refinery in Silvertown, London. Duncan, the pioneer and senior partner in the firm, was to manage the new venture.

Silvertown was named after Samuel Winkworth Silver, who in 1852 had opened his India Rubber, Gutta Percha & Telegraph Cable works in the London borough of Newham, downriver from London's traditional docklands. Silvertown had developed into an important industrial area catering for a labour force that was moving out from the city's overcrowded East End. A railway link was installed in 1847 and Victoria Docks, established in 1855, provided easy access for shipping.

Land here was cheap, and in 1861 Bell, Duncan and Scott leased six acres of riverside property with space to develop its huge refinery and the Clyde Wharf, where the raw materials were delivered and the finished products transported. The firm retained close ties with Greenock, purchasing for the refinery large vacuum pans manufactured in Greenock by James Duff & Sons which were "fitted up" in 1864, the

year that the Clyde Wharf refinery became operational. In the years up to 1869 the partners enjoyed huge success, producing 2,000 tons of sugar each week. Bell retired in 1869 and Scott returned to Greenock, where he continued to operate as Alex Scott and Sons. Duncan continued on his own as Duncan & Co., with offices at 9 Mincing Lane, London and a residence at 5 Highbury Hill, one of the grandest parts of Islington.

In 1869 Duncan adopted the continental method of creating sugar from sugar beet. He was the first in Britain to realise the potential of making sugar from beets, reputedly conceiving the idea after seeing a sample of sugar so produced at the Dublin International Exhibition of 1853.

In an attempt to enable English farmers to enjoy the same success as their German counterparts, the most prolific manufacturers of beet sugar in Europe, Duncan pioneered the cultivation of sugar beet in Lavenham in Suffolk, where, between 1868 and 1869, he built a refinery at a cost of £12,000. From the beets the farmers provided, syrup was made before being sent to Clyde Wharf for processing.

Among the first to support Duncan's venture was John Kersley, a wealthy landowner in Aylesbury. In his *Recollections of Old Country Life*, he recalled an attempt to grow white Silesian beet for Duncan's factory. After visiting it with two of his neighbours with large local farms, they "returned fully impressed with the certainty that this new departure in agriculture could be profitably carried out". Kersley wrote to the

"most eminent seedsmen in Belgium and the north of France" requesting the best-selected seed. He concluded ruefully that "owing to the duty of twopence per pound being put upon all sugar, and from the apathy of the farmers around Lavenham, Mr. Duncan was unable to get sufficient roots to profitably employ all his machinery. He therefore gave up the factory, and my scheme fell through."

Duncan's venture was also hindered by the local authority's objection to the effluent in the river Brett, on whose banks the refinery was built. Local opposition was so fervent that at one point it verged on sabotage. What is more, the farmers could not produce sufficient beet to make the operation viable. Nevertheless, in 1901 Duncan's venture was recognised as "the only serious and persistent attempt" to establish this particular form of the "sugar industry" in Britain.

Undeterred by his experience in Suffolk, Duncan continued to use continental beet for his factory in Silvertown, now one of the largest in London. George Martineau, himself an authority on sugar and an important refiner of the period, described Duncan as the "prince of sugar refiners", where his "enterprise was unbounded, and his success undisputed". By 1870, aged only 36, Duncan's wealth was colossal.

▼ James Duncan's sugar refinery in Lavenham, c. 1870s. By kind permission of Suffolk Record Office (SROB KPF LAV 177).

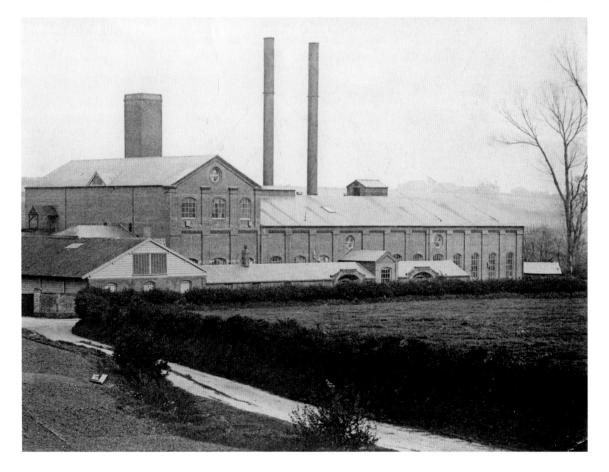

Duncan as Philanthropist

Duncan, however, had gained a reputation not only as a brilliant entrepreneur but also as a man deeply committed to helping those less fortunate. Described by one contemporary as a man "in whom was blended industrial genius with religious and philanthropic zeal", Duncan dedicated himself to improving the conditions of his workforce and those living in the area.

When Duncan arrived in Victoria Docks, it was in a state of great neglect. Silvertown was built on Plaistow Marsh, a "great expanse of ditch and pasture" named after Plaistow village, the nearest populated locality – the largest in the Essex parish of West Ham. The marshes had small, insubstantial wooden houses on them; drainage was into stagnant ditches; and the poorly maintained and unlit roads flooded regularly in winter. In *Household Words* (1857) Dickens observed that this was an area where only the poorest lived. Fever and ague were endemic and the mortality rate was higher than average.

Long before it was universally adopted, Duncan reduced the working day to eight hours for his men. For working in hot temperatures, he provided them with ale brewed on the premises. When his mechanics requested a 50-hour working week, Duncan granted it. In addition, Duncan paid his doctor £300 per year to attend to his 3,000 men,

◀ Photograph from 1888 showing the open 'Little Tommy Lee' sewer in the Canning Town area of London. It was conditions such as these that prompted much of Duncan's philanthropic work in the area. Photo: Newham Heritage and Archive Service.

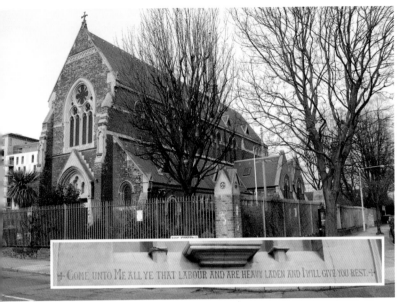

+ COME UNTO ME ALL YE THAT LABOUR AND ARE HEAVY LADEN AND I WILL GIVE YOU REST. +

▲ Main and inset:
St Luke's Church,
Canning Town, London,
one of the churches to which
Duncan was benefactor.
Photo: RBGE/
Hamish Adamson.

as well as funding an annual seaside holiday for his workers and their families. Clearly moved by the plight of those in the surrounding area, he organised sick relief for the whole district and "founded or sponsored" other initiatives to help the poor. By the late 1860s Duncan was giving away an astonishing £20,000 per year to charitable causes. All this brought him into close contact with various church organisations.

Duncan was both a member of the Free Church of Scotland and a Congregationalist who attended Dr Alexander Raleigh's Church at Highbury. Having said that "any spiritual life is better than none", Duncan gave donations impartially to all the major denominations. It was in the 1860s that he made the acquaintance of the Rev. Dr Henry Boyd, who was vicar of St Mark's, Victoria Docks between 1862 and 1875. Boyd, who was also committed to helping the poor in Plaistow,

recalled how Duncan's "interests did not always run with the work of the Church of England", but that he was "always ready to help in schemes for the social advantage of the district". Boyd also remembered how Duncan had generously helped him "in the early days of the Working Men's Club" which he had established near the Tidal Basin Station, and "which was eventually removed to the Boyd Institute". Duncan acted as treasurer of the committee formed to oversee the building of the Institute, and was the principal donor, contributing £500.

In 1868 Duncan built the Congregational Church in Victoria Dock Road, opposite Tidal Basin Railway Station, paying the minister's stipend and financing annual treats and excursions for the Sunday school children. A large number of Duncan's workforce was Presbyterian, and in 1873 he funded the building of the Presbyterian Church of England, also in Victoria Dock Road, at a cost of £2,000. This included an annual sum of £150 over a three-year period to support its ministry and thereafter £50 per year for the minister to work with children. So unusual was Duncan's commitment to this and to Boyd's project that the Synod of 1874 recorded their "deep sense of the generosity displayed by Mr James Duncan – all the more grateful in that he is a member of another Christian Communion". Perhaps even more unusual, given Duncan's Free Church background, was his support of the Roman Catholic Church, showing a liberality of outlook rare in any era.

Duncan was involved in another public venture that was to have a permanent effect on London's landscape. In 1868 John Gurney, grandson of Samuel Gurney, the Quaker banker, philanthropist and Member of Parliament who supported the anti-slavery movement, offered Upton Park for public sale at half its market value of £30,000 for use as a public garden. This inspired various fund-raising events. John Curwen, a well-known Congregationalist in Plaistow, "headed a small band of public-spirited people who advocated the purchase, and he gave up several weeks to the agitation, fighting with much energy".

Following a protracted period of fund-raising lasting six years, all public revenues and private subscriptions had been used up, leaving a shortfall of £400. Gurney's secretary, Gustave Pagenstecher, went in despair to Clyde Wharf to see Duncan in the hope of securing a donation. "Go to my cashier," Duncan reputedly said, "and he will give you a cheque for £400." Pagenstecher later reflected, "I stood in wonder and amazement and scarcely knew what to say. I shall ever feel that I owe a deep debt of gratitude to that gentleman who could act so handsomely and nobly to an utter stranger as I was to him at that time. My mind was relieved of a great burden and the purchase of the park was now assured". The Mayor of London formally opened West Ham Park at a grand ceremony in 1874. Few would have known that the grounds, second only to Kew at the time, might well not have come into

◀ Decorative urns at the Terrace area of West Ham Park. Photo: RBGE/ Hamish Adamson.

public ownership but for Duncan's crucial donation.

By 1867 Duncan was well established in London. He was, however, planning a new venture north of the border. In 1870 he bought the estate of Benmore, Argyllshire, reputedly from the "profits of a single year's work". Situated across the water from Greenock in the Argyllshire hills, it was a setting that Duncan had often gazed on as a boy from his house in Mosesfield.

▼ The South Gate of West Ham Park, c. 1904. Photo: From the records of West Ham Park, which is owned and maintained by the City of London Corporation.

Benmore

Duncan bought Benmore House and its 12,500-acre estate for £105,000 from the Scots-American tobacco tycoon James Piers Patrick in October 1870. Like many Victorian entrepreneurs who had made vast fortunes, it was natural for Duncan to aspire to the aristocratic ideal of owning a country seat. Few, however, had Duncan's energy. In the space of 15 years, spending a further £100,000 "in buildings, planting, and improvements of all kinds", he gave full vent to his ambitious and creative vision, revitalising and cultivating his estate.

Duncan now divided his time between London and Benmore.

By 1873 he had moved into an impressive new residence at 71 Cromwell Road, Kensington, where he lived for most of the year, except for the summer months spent north of the border. In October 1871 he had a telegraph wire installed at Benmore so that "he could direct the working of his factories and the operations of his gigantic business in London".

In addition to its "altogether magnificent" situation, Duncan gave a further explanation of why he chose Benmore. The occasion was a dinner held at Strone on 15 June 1872 by "the feurs and resideaters of Kilmun, Strone, and Blairmore, and other

▼ Photograph of Duncan family, c. 1870–1875. Left to right, John Moubray, Janet Duncan, George Duncan, Mary Duncan, Clementina Duncan, Mary Moubray, James Duncan. By kind permission of Fiona Marsland.

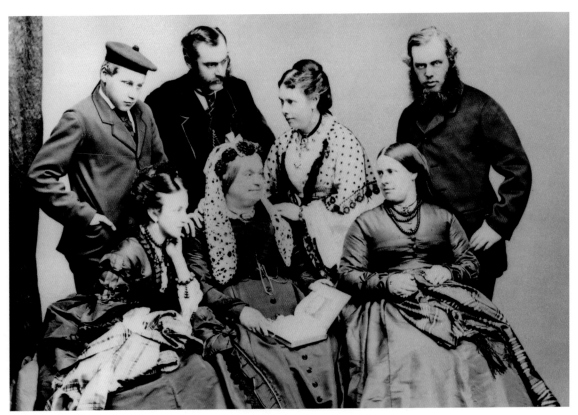

gentlemen belonging to Glasgow, Greenock, & c., in testimony of their respect for his personal character as a landlord and gentleman, and his successful career as a merchant". Among the guests were James Reid, Chairman of Hyde Park Locomotive Works, Springburn, and William Teacher jnr of Kilmun, who inherited his father's wine and spirit company.

Following the Chairman's speech, Duncan began his address by saying that he was "delighted to see his old partner" Alexander Scott, "a man he held in the very highest respect". He then recalled that when he mentioned his intention of returning to Scotland, some of his English friends, perhaps with the advice of Dr Johnson in mind, considered "he was joking, as they said it was a most unusual circumstance for any of his countrymen to return to Scotland when they had once crossed the Border". But for Duncan, "This property had attractions for him which few others had. From it he had Greenock before his eyes, and in Greenock his success in life had begun [sic]" and although "Glasgow was his native place, he had always a liking to be near Greenock". He also mentioned that another "circumstance which made this property attractive to him was that in 1857, while on board a steamer in Lochlong, he had conceived the idea of sending out sugar from the refinery without syrup". This confirms Duncan as the innovator in Bell, Duncan and Scott.

By the time this banquet took place, Duncan had already shown his commitment in manifold ways to the poor in the area. He made arrangements whereby the "nine hours movement"

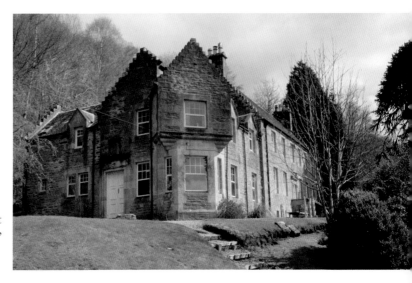

▲ A present day view of Old Kilmun House (1693), Kilmun, Argyllshire. This view shows David Thomson's 1874 additions. Photo: Peter Clarke.

was implemented to the benefit of his workforce; "each minister on the Kilmun shore" received a "handsome donation from Mr Duncan for the relief of the poor and necessitous"; and in 1871, in conjunction with the Glasgow Abstainers' Union, he established a home at Kilmun for the "benefit of the sick poor in the West of Scotland". Duncan initially offered Old Kilmun House (built 1693) for this purpose.

Such was the demand for places that larger, purpose-built accommodation was required. In 1872 the Glasgow architect Hugh Barclay produced sketches which were sent to Duncan for his approval. Duncan duly agreed, providing £800, a plot of land and stone from his quarry. In May 1873 Duncan laid the home's foundation stone and presided at its opening in August.

Duncan was involved in other local projects. In 1871 a meeting of residents had taken place to discuss the "unsatisfactory condition" of Kilmun churchyard and the "want of suitable places of interment". Duncan's factor, Alexander McNeil Caird, reported at

▶ View from A'Chruach (Cruach) hill towards Holy Loch, showing Benmore Botanic Garden and policies. Cowal, Argyllshire, by Robert Moyes Adam, November 1929. Photo: Courtesy of the University of St Andrews Library (RMA–H2158).

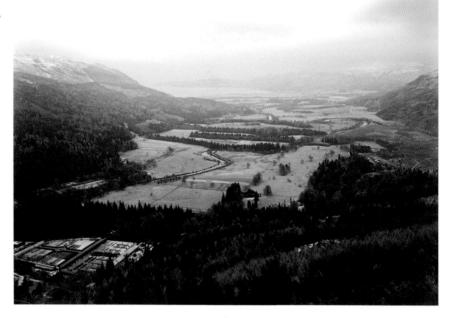

▼ Engraving of Benmore House, c. 1860s? (source unknown).

the meeting that with "usual liberality, [he] had anticipated the wants of the community, and was prepared to grant a piece of ground". In the following year he also gave land to the School Board of the United Parishes of Dunoon and Kilmun to build a public school.

Those who attended the meetings associated with these projects were also aware of Duncan's extensive improvements to his estate, which began in 1871. The land extended from the Firth of Clyde to the north end of Loch Eck, including a frontage of five miles to Loch Long. Duncan's forester, Donald Stalker, described the northern boundary of the estate as "extending along and rising above the western margin of Loch Eck for a distance of seven miles", a "continuous chain of hills, the highest being Benmore, about 2,500 feet high". According to Stalker, when Duncan first entered the estate, the "undulating and fertile valley of Eachaig" was in a "wild state of nature, overgrown with brushwood, heather and rushes". In his first year at Benmore, by tile draining and ploughing, Duncan cultivated all wasteland suitable for farming, "while on the moorish wastes and portions un-reclaimable he planted".

Duncan established various plantations on his estate, some in farmland and some near to the mansion house, all of which, according to one visitor, were in a "flourishing condition

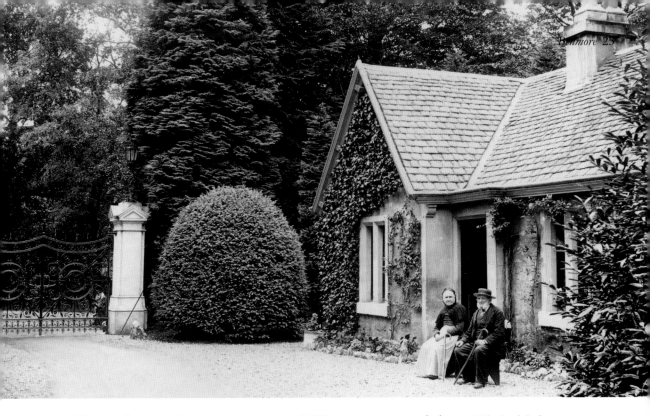

… as well kept and managed as any nurseryman's grounds near the large cities". The trees grown were intended for the local hillsides, "best adapted to the soil and most likely to thrive". In the plantation nearest Benmore House could be seen "beautiful larches, 60 and 70 feet high and perfectly straight". In the autumn of 1871 alone Duncan planted trees across 273 acres, including Uig and Benmore Hills. In the following ten years 1,622 acres were covered, the number of trees totalling an impressive 6.5 million, the majority of which were larch, Scotch fir and spruce. The whole enterprise cost Duncan some £12,165.

As well as in the setting, Duncan evinced an interest in Benmore Mansion itself. An engraving dating from the 1860s shows Benmore House as it looked in 1870. Its distinctive baronial tower – added in 1862 – was designed by the Glasgow architect Charles Wilson, who had trained under David Hamilton, architect of New Mosesfield House. In 1874, when extensions were made to Benmore and other buildings were erected, Duncan, like his father, engaged one of Glasgow's leading architects, employing David Thomson who had a reputation for building country houses.

Thomson probably served his apprenticeship between 1845 and 1855 in Wilson's office and was his assistant until 1862, when he became a partner in Wilson & Thomson. In 1862 he

▲ The South Lodge of the Benmore Estate with Duncan's golden gates in the background, c. 1890. Photo: Courtesy of David Younger.

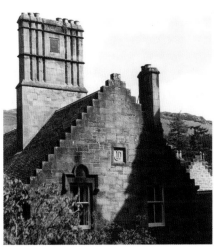

◄ Detail of David Thomson's 1874 additions to Benmore House. Duncan's initials can be seen in the centre of the wall. Photo: Andrew M. Watson.

▶ David Thomson's drawings of west elevation for his 1874 additions to Benmore House. © Courtesy of the Royal Commission on the Ancient and Historical Monuments of Scotland (DP 030065).

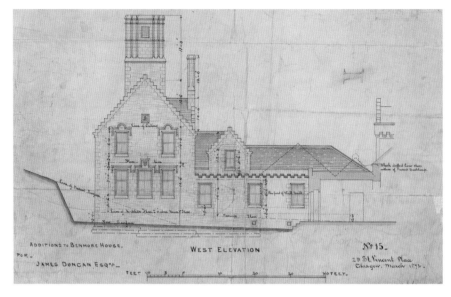

▼ Hugh Barclay (architect), Kilmun Convalescent Home (1873), Kilmun, c. 1921. Courtesy of Glasgow City Archives and Special Collections (TD432/20).

worked on Benmore, continuing the extension work and in 1866 designing the South Lodge. His knowledge of the house and grounds made him the logical choice to carry out work for Duncan.

In 1874 Thomson built kitchen and service accommodation, in the baronial style of the main building, around a courtyard on the north side of the house. The north west side of these additions bears the monogram JD. In the same year he also designed the factor's lodge and an additional building in the stable court

to accommodate Duncan's workforce. On the north east corner of the steading is a three-storey house with a cylindrical stair and tower in which Duncan installed a clock in 1875.

In 1874 Duncan also commissioned Thomson to make additions to Old Kilmun House, after it had ceased to be used as a convalescent home. Duncan also built a fernery that year. This added another special feature to his estate.

Duncan's interest in ferns was part of a nationwide passion. In 1855 this craze was called "pteridomania" – fern madness. Wealthy landowners like Duncan, in establishing their own ferneries, "followed the examples of the nurserymen and botanic gardens" whose pioneering work earlier in the century was brought to a wider audience through publications. In 1878 Duncan Clerk, in his annual report on Argyllshire, mentioned, "Among the many classes of plants attended to at Benmore, ferns are not forgotten. This is as it ought to be … and there is no place where they will thrive better than in Argyllshire."

Situated in Glen Massan on the south west facing hillside of Benmore estate, Duncan's fernery (most probably designed by Thomson) was built on a steep slope flanked by trees, access to which was by a winding path. The types of fern that Duncan cultivated would certainly have been interesting specimens, especially since Duncan received advice from Sir Joseph Dalton Hooker, director of Kew gardens from 1865 in succession to his father, Sir William Jackson Hooker, a specialist in ferns, whose magnum opus was the five-volume *Species Filicum*. Duncan's fernery was the first of its type in Argyllshire and it was not until 1879 that another was built in the region. Clerk's comments on the suitability of Argyllshire's climate for ferns were not lost on Alexander Bannatyne Stewart of Ascog Hall in Bute. In 1879 he employed the architect Edward La Trobe Bateman to design his own fernery.

On the north east side of his estate Duncan built huge greenhouses, one of which was 325 feet long with a 30-foot-wide conservatory in the middle. These were all certainly in place by 1878 when, according to Clerk, "the range of greenhouses and the extent of ground covered with glass is wonderful". He commented on the wide range of plants and flowers to be seen, including "stove plants, greenhouse plants, bedding out plants, border flowers, and annuals of every kind and description", the range and quality of which "would be admired in any part of the kingdom". According to another writer, these contained the "finest collection of Camellias in Scotland". By September 1883 Duncan "had made considerable additions to his greenhouses" which, it was reported, were "the largest in Scotland".

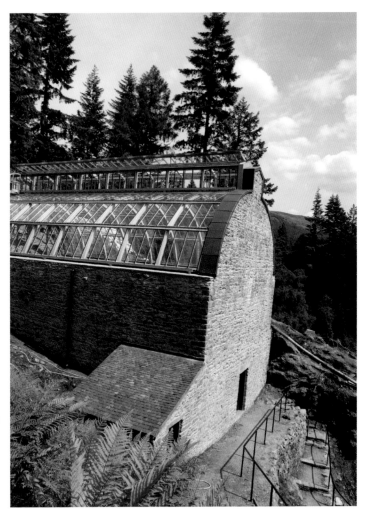

▲ The restored Benmore Fernery, Benmore Botanic Garden, 2009. Photo: RBGE/Lynsey Wilson.

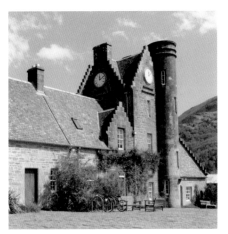

◄ **Left:** Clocktower at Benmore Botanic Garden as it looks today. Photo: RBGE/Peter Clarke.

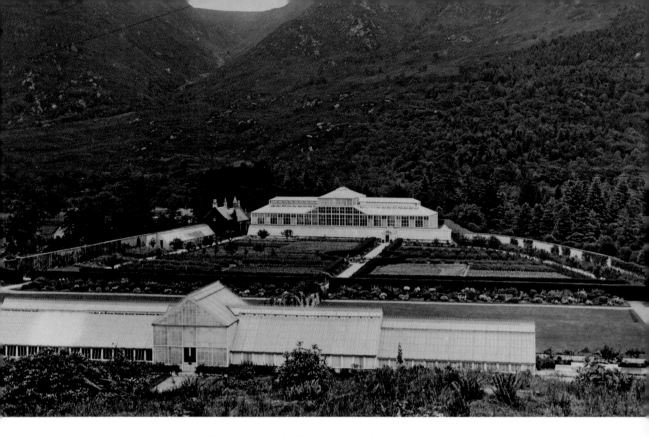

▲ The greenhouses and Formal Garden at the Benmore Estate in the 1890s. Photo: Courtesy of David Younger.

Duncan was similarly dedicated to cultivating livestock. In May 1876 a local writer mentioned how "the preserves at Benmore are numerous and valuable, and include hen coops, pheasant coops, duck ponds, rabbit warrens, hare warrens, deer parks, and artificial trout tanks". Duncan also installed a large salmon farm. But he was perhaps best known for his cattle and sheep, which featured regularly at the annual Highland Association gatherings. Duncan grazed his West Highland cattle and black-faced sheep in the fertile valley of Eachaig. From 1875 onwards these cattle were celebrated, winning first prize in their category in 1877 at the Highland Society's Edinburgh show. On 8 June 1878 *The Scotsman* reported that both the cattle and sheep were awarded first prizes at the Paris International Exhibition.

Alongside his passion for livestock, trees and delicate ferns and plants,

Duncan, "always at work, always thinking out some new scheme", used Benmore to initiate new entrepreneurial schemes and further chemical research. As early as May 1873, it was reported in the local press that at Benmore "an effort to provide a substitute for coal" was "in progress, on a considerable scale". Duncan excavated peat from Benmore Hill and had machines installed on the estate to dry and mould

▶ Cattle grazing in the pastures of the Benmore Estate in the 1890s. Photo: Courtesy of David Younger.

the peat into blocks. It was then taken by steamer for sale in Glasgow with the aim of selling the fuel at a lower cost than coal. In 1877, it was reported that Duncan "became impressed, from several indications on part of his land, that silver and lead might be found in the district, and at once consulted with several mining engineers of eminence" who, "on examining the ground, gave it as their opinion that silver and lead did exist to an extent that would make the working of it profitable". The writer concluded that "Mr Duncan then has ordered the necessary machinery for excavating, and in a short time the silver mines of Benmore will be at work."

In his fields Duncan used steam engines and other state of the art machinery. In the 1870s he built another sugar refinery where he could conduct research, though little is known about the building and what it produced. All these ventures attest to Duncan's energetic and innovative spirit.

By the late 1870s Duncan's achievements as a man of commerce and science were widely recognised. In addition to his work on sugar, he was also acknowledged as an authority on the extraction of essences from the coffee bean. He became Chairman of the Railway and Canal Traders' Association, Vice President of the Society of Chemical Industry and, as the authority on sugar, in 1879 succeeded Augustus William Gadesden in the prestigious position of Chairman of the Sugar Refiners' Committee.

Such was Duncan's reputation as a man of scientific enterprise that, when the British Association for

▼ View from the 1890s across Strath Eck to the Formal Garden, Stable Courtyard buildings and, to the right, Duncan's experimental sugar refinery. The mound above the greenhouse on the left of the picture is where the crowds gathered in 1877 to listen to Spurgeon. Photo: Courtesy of David Younger.

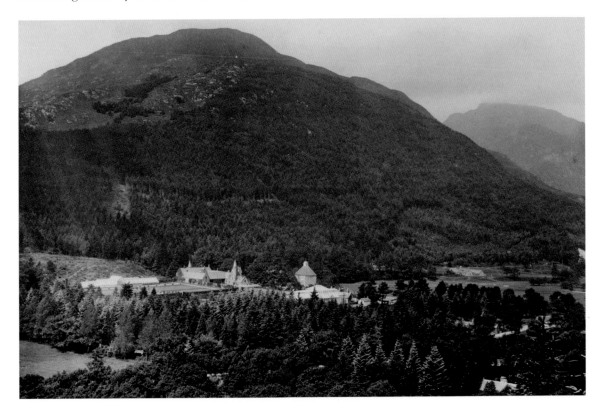

▶ Photograph of
Charles Spurgeon, 1875.
Courtesy of Spurgeon's
College, London.

▶ John Adams-Acton,
bust of Charles Spurgeon,
(1874) (marble).
The inscription on the
plinth shows that Duncan,
William McArthur M.P.
and George Wood presented
the bust to the college on
30 December 1874.
Courtesy of Spurgeon's
College, London.
Photo: Judy Powles.

the Advancement of Science met in
Glasgow in early September 1876, part
of the week-long programme included
an excursion to Benmore. *The Scotsman*
reported on 1 September, the day
before the visit, that Duncan was
"to entertain upwards of three hundred
members" at his "beautiful residence
of Benmore". The members went
by train to Greenock and thence by
steamer to Loch Fyne before "driving
to Benmore by way of Loch Eck".
It was maintained that those who
knew this route would "appreciate
Mr Duncan's scheme, for finer scenery
could not be desired than that to be
witnessed on the road from Strachur
to Benmore". Duncan provided the
party with dinner and, in addition to
this "liberal hospitality", he "issued
invitations to between thirty and
forty gentlemen to go on a dredging
expedition down the Firth in his steam
yacht", Duncan bearing the expense
of the whole programme.

During the 1870s and 1880s
Duncan entertained many of his
London friends (most of them
churchmen) at Benmore. Boyd
recalled how for many years he
"paid a pleasant visit in the summer"
to Duncan's "beautiful place". Curwen
spoke of the beauty of the estate, and
the Pastor of Upton Baptist Chapel,
William Williams, also stayed there.
Duncan was revered in Baptist circles,
having gifted £1,000 to the building
of the Baptist Tabernacle in Barking
Road, Plaistow in 1876. The most
celebrated of Duncan's visitors was
the Congregationalist preacher
Charles Hadden Spurgeon.

Spurgeon rose to fame as a young
preacher in the 1850s, when he drew
unprecedented crowds. In September
1855 he preached to "12,000 people in
a field in Hackney; and nearly 24,000
heard his address at the Crystal Palace
in October 1857". To accommodate
Spurgeon's growing congregation,

funds were raised to build the
Metropolitan Tabernacle (1859–1861),
designed by William Willmer Pocock.
In order to reach an even wider
audience, Spurgeon published many of
his sermons and in 1865 began his own
monthly, *The Sword and the Trowel.*

By 1876 Duncan and Spurgeon
were firm friends. Between then and
1878 the preacher spent his summer
holidays with Duncan at Benmore,
returning again in 1880 and 1885.
As well as offering the hospitality
of Benmore, Duncan entertained
Spurgeon on his steam yacht
The Varina. Although Spurgeon's visits
were intended as holidays, the Highland
community was so appreciative that he
was asked to preach numerous open-air
sermons in various parts of Argyllshire.
In his autobiography he recalled that
he did not "know a prettier site for
a sermon than the one which I have
many times occupied in the grounds
of my friend, Mr James Duncan, at
Benmore. It was a level sweep of lawn,
backed by rising terraces covered with
fir trees." These sermons "proved a
pleasant labour of love" and it stirred
Spurgeon's "heart to see the thousands
flocking to that out of the way place
to hear the gospel". He also revelled
in the "noble scenery, well-stocked
gardens, rivers, lochs, glens, mountains
and woods".

In July 1877 Spurgeon preached
outdoors in Dunoon to a crowd of
7,000. At six o'clock the same day
almost 2,000 who gathered at Benmore
"had come long distances to hear the
prince of preachers". The position
chosen was the "garden in front of the
greenhouses, facing the road to Loch

Eck ... laid out in green terraces with
plots of the most rare and beautiful
flowers". A platform was erected
for Spurgeon and, though a few seats
were provided, the majority of his
congregation sat on the grass. "Here
and there a gap was seen in the crowd,
which was occasioned by a bed of
exquisite flowers, which, with the rich
green background of grass and foliage,
gave to the scene a picturesqueness
which can hardly be described."

It was probably in 1877 that the
Baptist pastor William Williams joined
Spurgeon and Duncan at Benmore.
Williams provides a rare glimpse into
Duncan's sense of humour. It was his first
visit to the estate, and Duncan asked
him, "Can you shoot, Mr Williams?"
When this was confirmed, Duncan
immediately offered to "send to
Glasgow for a gun licence". Spurgeon
told Williams that if he could shoot
the stag as he lay in Duncan's meadow,
he would be given a haunch of venison
to take back to London, cautioning
him with Duncan's advice that if he

▲ Lawn in front of
Benmore House where
Spurgeon preached in
1880 and 1885.
Photo: Andrew M. Watson.

did not shoot him sitting down he would not succeed at all, because he was a "very unusual sort of stag". At dusk Williams went after his prize, only to find, as he got to within firing range, that the stag was unusually still, being made of bronze. Having taken the joke in good part, Williams concluded, "a tougher piece of venison than I should have liked to bring to London, was that stately monarch of the meadow".

In July 1878 Spurgeon travelled on Duncan's yacht to Oban and Rothesay, where he preached to 12,000 people. Following a bout of bad health in 1879, he returned to Benmore in 1880 and preached to a crowd of 3,000, this time on the lawn in front of Benmore House. Duncan sent the £32 collected at the service to the secretary of the Abstainers' Union for the benefit of the Convalescent Home. Spurgeon

made one more visit in 1885, and his sermon in front of 4,000 on Duncan's lawn was the last at Benmore, marking the end of such large-scale gatherings. Ailing health affected Spurgeon thereafter, evincing a letter of concern to him in 1885 from Duncan's sister, Mary Moubray. It brought a reply from Spurgeon in which he told her, "Happy woman to be sailing over the fair seas, and gazing upon those glorious hills! … I saw Mr Duncan on Sunday, much to my joy. He is, indeed, a kind and tender friend, and his sister is like unto him. God bless both!"

In December 1879 Duncan made arrangements for the marriage of his younger sister Clementina to Captain Hector Lassalle, whose regiment was stationed in Bombay. One journalist felt that the occasion was a "fitting opportunity for displaying not only the

▼ The façade of Benmore House with Duncan's picture gallery to the right with the bronze stags in the meadow in the foreground, c. 1889–90. Photo: Courtesy of David Younger.

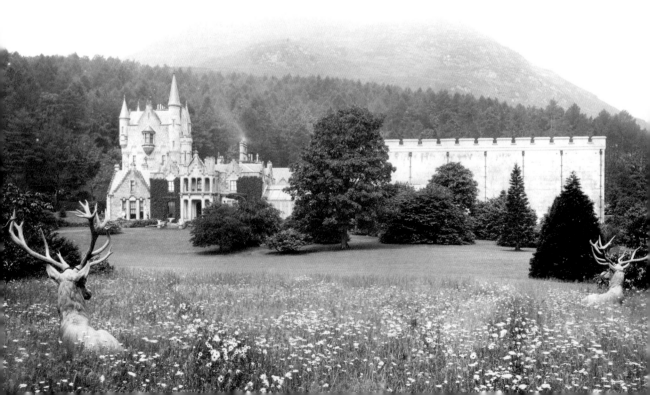

▲ Gustave Doré, *Glen Massan*,
c. 1870s. Oil on canvas,
112.7 × 184.8 cm.
Kelvingrove Museum,
Culture and Sport Glasgow
(Museums). Given by
Dr and Mrs W. Muir Robertson
1979 (3352).

devotion of the parishioners towards
Miss Duncan – a lady every way
estimable – but also the emotions of
pride and admiration with which the
proprietor, generous and enterprising,
is regarded". Along the coastline
one could view "decorative arches,
festoons, flagpoles and huge bonfires
… every now and then discharges of
rockets and small canon were heard
reverberating from hill to hill".
Several private houses were also
festooned, and the convalescent
home was "radiant with flags and
lanterns". Clementina sent the
home a "kind note of adieu" with
a donation towards their funds.

Following the ceremony, the
presentation of gifts and the departure
of the bride and bridegroom,
Duncan opened a celebratory ball
with a "few graceful words befitting

the surroundings". The *Dunoon Observer
and Argyllshire Standard* recorded that
the "workmen, with their wives,
were munificently entertained in the
Picture Gallery, scarcely yet completed
but fitted up for the occasion … The
Band played some fine airs, and soon
the large hall – 163 feet in length by
60 in breadth – became a scene of
joyous and animated commotion."

This account of Clementina's
marriage is the only known source to
provide a date for one of Duncan's
most ambitious additions to the
architecture of Benmore – a colossal
picture gallery built to house his
paintings and sculptures. For in
addition to his many other activities
and achievements, Duncan assembled
a collection of art of no ordinary
kind, gaining a reputation as one of
Europe's most discerning connoisseurs.

Patron of the Arts

Duncan inherited his father's ability to engage with architects and artists, but differed in his commitment to the fine arts. For just as the industrial climate had changed markedly from the one Duncan's father knew, so too had the artistic world – largely as a result of the vast wealth that manufacturing had brought to the merchant class. Duncan's generation was the first to contribute to and benefit from the proliferation of international exhibitions of industry and art organised across Europe from the mid 19th century onwards.

In 1851, at the beginning of a period of great economic expansion, Britain – the world's most progressive industrial nation with a sophisticated network of foreign markets – pioneered this era of international exhibitions when it held the Great Exhibition of Works of Industry of All Nations at the Crystal Palace. As well as demonstrating cutting-edge developments in industry, the organisers also showcased the fine arts through the exhibition for the first time of sculpture.

Two years later, the nineteen-year-old Duncan attended the 1853 Great Industrial Exhibition in Dublin, showing how quickly he responded to new developments in the promotion of world trade and industry based on free trade principles, of which Duncan was a staunch supporter. Here he realised the enormous potential of the manufacture of beet sugar, which became the foundation for his success in London eight years later. The Dublin exhibition was the first World Fair to show paintings, involving significant continental works, the scale, style and subject

▼ General view of the exterior of Crystal Palace, London, 1851.
Illustrated plate taken from *Dickinson's Comprehensive Pictures of The Great Exhibition,* published in 1854.
Image: © Science Museum/ SSPL.

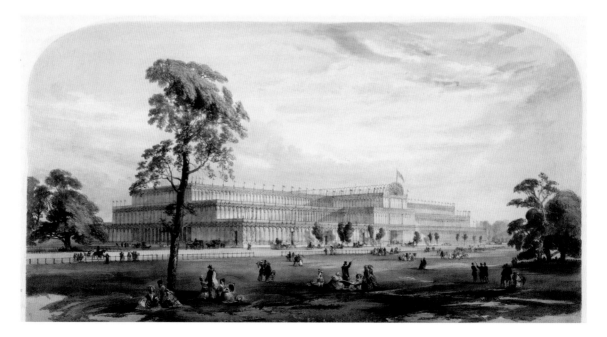

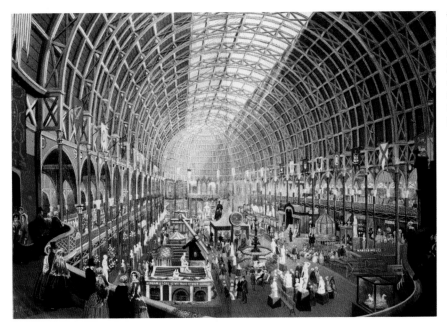

◀ The Centre Hall of the Great Industrial Exhibition, Dublin, Ireland, 1853. Coloured plate from *The Irish Industrial Exhibition of 1853: a Detailed Catalogue of its Contents*, published in 1854. Image: © Science Museum/ SSPL.

matter of which made a deep and lasting impression on Duncan.

Prior to the opening of the Dublin exhibition, a writer for the *Art Journal*, at that time the most important Victorian journal of its kind, claimed that besides industrial exhibits, its "principal purpose" was to "entreat the cooperation of collectors ... Those who lend make others rich without diminishing their own treasure [and] increase the renown of the artists they have patronised, while becoming the most effective and profitable of teachers." Thereafter major international exhibitions included displays of fine art. Duncan embodied the *Art Journal*'s sentiments, becoming a major lender of pictures and sculptures to some of the most significant exhibitions organised in Britain and elsewhere in Europe in the 1870s and 1880s.

Duncan and his fellow "merchant princes" also witnessed the growth of a flourishing art market in Britain, in which they assumed a key role, largely superseding the aristocracy as the main patrons of art.

By the 1860s the London art market was one of the most highly developed in Europe. Dealers' galleries played a major role in supplying and promoting works by living artists, bringing a new dynamic to collecting and effecting a major shift in taste for the old masters — the traditional preserve of the aristocracy — to a greater interest in contemporary art.

Throughout the 1840s and 1850s, auctioneers and print sellers often held exhibitions of contemporary art in rented accommodation. In 1848 this elicited the censure of the *Art-Union*, which encouraged collectors to buy directly from artists and avoid the venality of dealers. The *Art-Union* saw the Royal Academy as an ideal institution in which to exhibit, a model of economic neutrality and one

▶ Rosa Bonheur, *The Shepherd of the Pyrenees*, 1888.
Oil on canvas. 60.5 × 81cm.
Image: Courtesy of The Royal Pavilion and Museums, Brighton & Hove (FA000323).

committed to the public good. But the demand for art from the burgeoning middle class was such that by the 1860s a number of commercial galleries were established in London. Agnew's, Arthur Tooth and Sons, the Belgian Gallery and the French Gallery, run by the Belgian dealer Ernest Gambart, were among the most notable. Gambart promoted French artists including Rosa Bonheur, Paul Delaroche and Jean-Léon Gérôme, all of whom were eventually represented in Duncan's collection.

Duncan's artistic outlook was also to some extent influenced by his native city, which developed a special relationship between its artistic and industrial fraternities. In 1861 the Royal Glasgow Institute of Fine Arts was inaugurated and held its first exhibition at the McLellan Galleries in Sauchiehall Street. It was composed of local artists, Members of Parliament and a number of gentlemen — many of whom came from the mercantile class — "well known for their taste and discrimination in Art matters". The artists included the painter John Graham, who later became Sir John Graham-Gilbert, and the sculptor John Mossman, son of William Mossman I, who had worked for Duncan's father. Henry Simson, a local businessman, chaired the initial meetings that led to the Institute's successful launch. The Royal Glasgow Institute of Fine Arts accepted loans from collectors and sold works by living artists. From the time of its institution, it represented a cosmopolitan outlook. In 1861 Thomas Coats of Ferguslie lent *Sheep in a Meadow* by Bonheur to its inaugural exhibition. Throughout the 1860s contemporary Dutch art was also exhibited there, with pictures by Hague School artists such as Jacob Maris and Josef Israels proving most popular.

In 1870 Duncan's dedication to the arts was confirmed when he was elected an Extraordinary Member of the Royal Glasgow Institute of Fine Arts, one of a distinguished group of eleven

"eligible for election as President or to any other office". Fittingly, Duncan made his first recorded purchase of a painting at the Glasgow Institute that year. On 5 April he paid £48 for *The Donkey's Story* by the fashionable Dutch animal painter Henriette Ronner-Knip, whose sentimental paintings of cats found special favour among Victorian collectors. Although this was hardly one of Duncan's most important purchases, it nonetheless demonstrated his commitment to European art and heralded an expansive, intense period of buying.

The sugar trade took Duncan to its major European centres in Germany, Austria and France, where he examined the art of these countries, especially when in France. In the 19th century, Paris was the artistic centre of Europe, a city that nurtured and attracted the greatest living artists. It had some of the finest public galleries in Europe, the Louvre being its most important. Since the late 18th century, the Salon of the Académie des Beaux-Arts in Paris had become the greatest annual or biannual art event in Europe, attracting tens of thousands of visitors. Works shown were often large-scale figurative pictures depicting historical or mythological themes, *grandes machines* as they came to be known. Like the Royal Academy in London, the Salon exhibited and marketed modern art that upheld traditional values, which were enshrined in and promulgated by the 14 members of the Académie des Beaux-Arts, whose job was to select pictures for exhibition, award prizes and elect suitable replacement members. Although the formation of

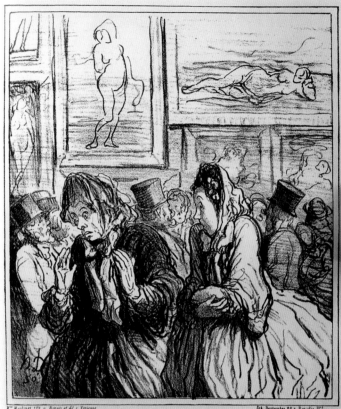

− Cette année encore des Vénus.... toujours des Vénus !... comme s'il y avait des femmes faites comme ça !....

this body underwent various changes throughout the 19th century, its power was pervasive. As Auguste Renoir noted in 1881, "in Paris there are scarcely fifteen collectors capable of liking a painter without the backing of the Salon. And there are another eighty thousand who won't buy so much as a postcard unless the painter exhibits there." Although Duncan was more independent than the collectors Renoir had in mind, he nonetheless recognised the talent of Gérôme, Ernest Meissonier, Jean-Jacques Henner, William Bouguereau and Jules Lefèbvre, all of whom did exhibit at the Salon, eventually purchasing representative canvases by each artist.

▲ Drawing by Honoré Daumier from *Le Charivari*, May 10, 1865 depicting two ladies' reaction to that year's salon at the Salon of the Académie des Beaux-Arts in Paris. The cartoon is captioned: "Cette année encore des Vénus ... toujours des Vénus! ... comme s'il y avait des femmes faites comme ça!" ("Still more Venuses this year ... always Venuses! ... as if there were any women built like that!"). Image: © www.daumier-register.org.

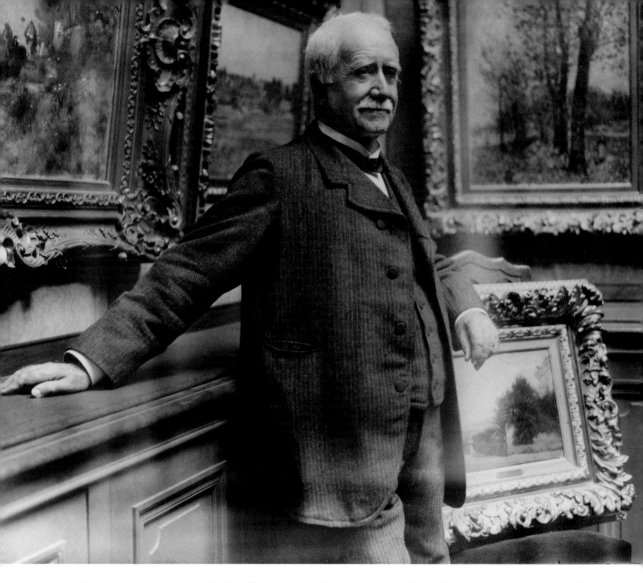

▲ Paul Durand-Ruel in
his gallery, photo Dornac,
c. 1910, Archives Durand-Ruel
© Durand-Ruel & Cie.

In Paris Duncan visited the main
picture dealers whose premises were
in the area north east of the Place de
l'Opéra near the Boulevard Haussmann.
In the Rue La Fayette, the picture
dealer Louis Latouche specialised in
Salon works and watercolours, and in
rue St Georges, Georges Petit initially
sold fashionable Salon pictures as well
as works by Édouard Manet, before
eventually promoting Impressionist
pieces. The two dealers known to have
influenced Duncan are today recognised
as the most famous and influential:
Goupil et Cie, whose main saleroom
was in the Place de l'Opéra, and Paul

Durand-Ruel, whose premises had
entrances at the Rue Laffitte and the
Rue le Peletier. Durand-Ruel formed
close ties with Duncan, who became the
dealer's most important British client.
It was from Durand-Ruel that he bought
some of his first key French pictures.

By 1870 Durand-Ruel was well
known as a dealer representing artists
as diverse as Bouguereau, Gabriel
Decamps, Camille Corot, Théodore
Rousseau, Narcisse Diaz de la Peña,
Charles Jacque and Jules Dupré, the last
four of whom came to be known as
the Barbizon School, whose romantic
landscapes, often with highly charged,

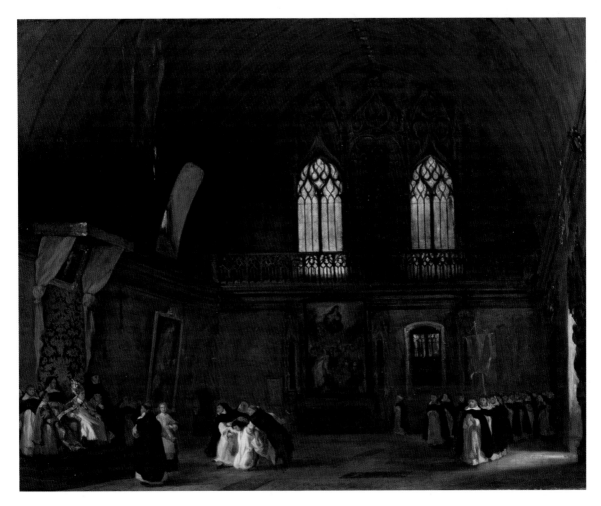

expressive brushwork, were at the heart of Durand-Ruel's aim to promote a type of work typically French in character. At the head of the French school was the great romantic painter Eugène Delacroix, who was widely recognised in France as a towering genius of the 19th century and a source of great inspiration to the generation of younger French artists. Durand-Ruel supplied masterpieces to some of the greatest collectors in Paris, including Delacroix's *The Murder of the Bishop of Liège* (1829, Musée du Louvre) to the Ottoman diplomat Khalil Bey, and works by Delacroix to Bey's friend,

the Anglo-Levantine financier Charles Edwards.

Edwards lent money at interest to Durand-Ruel to ensure that the dealer could purchase and then sell high-quality works, an arrangement financially beneficial to both parties. In 1870 Durand-Ruel organised a sale of pictures from stock by artists whom he most prized, including 11 by Delacroix. To increase the cachet of the sale he fronted it with Edwards's name, creating the impression that the works were from a famous collection. Writing under the pseudonym of Jean Ravenel, Alfred Sensier reviewed "Edwards's"

▲ Eugène Delacroix, *Interior of a Dominican Convent in Madrid*, 1831. Oil on canvas, 130.2 × 161.9 cm. Philadelphia Museum of Art, purchased with the W. P. Wilstach Fund, 1894 (W1894-1-2).

▶ Camille Corot, *La toilette*,
1859. Oil on canvas,
150 × 89.5 cm.
Private Collection, Paris.
Image thanks to the
Art Renewal Center®
www.artrenewal.org.

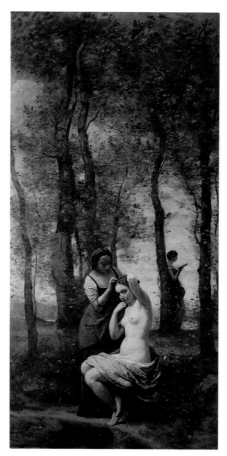

collection in the *Revue internationale de l'art et de la curiosité*, in which *Interior of a Dominican Convent in Madrid*, depicting a scene from the Gothic novel *Melmoth the Wanderer*, was highlighted as "one of Delacroix's most noble compositions, worthy of a museum or a prince's palace". It was a picture destined for Duncan's collection.

A few months after the Edwards sale, the Prussian army invaded Paris. Like Claude Monet and Camille Pissarro, Durand-Ruel fled the city, eventually settling in London. He and Duncan most probably met there in the early 1870s, when the dealer was organising a number of exhibitions of French art at his Bond Street gallery, which

operated as the Society of French Artists. Duncan bought his pictures from Durand-Ruel's Paris gallery, certainly after 1871 following the end of the Prussian siege. According to an unpublished memoir, Durand-Ruel "vainly tried to sell" *Interior of a Dominican Convent in Madrid* at the Edwards sale, before later selling it to Duncan. The precise date of acquisition is not known, but it was probably around 1873 when the dealer had it on show in his Paris gallery. The picture was the first major work by Delacroix to find its way into a British collection, and was one of Duncan's most significant early purchases, made at a time when no other Scottish collectors (and few non-French collectors) showed any interest in the artist's work. Another picture in Durand-Ruel's stock in 1873 was Corot's celebrated *La toilette*, today recognised as one of Corot's greatest works. After buying the picture directly from the artist for 10,000 francs, some time in 1873 Durand-Ruel sold it to Duncan. This was another major early acquisition of French art in Britain, and among the first of Corot's paintings to be acquired for Scotland.

Following these initial exchanges, the relationship between dealer and client was very rapidly consolidated. Durand-Ruel's ledger records that between February and May 1874 Duncan bought five more paintings from him: *Bergère avec moutons et chiens* and an untitled landscape, both by the great realist painter Gustave Courbet; two paintings by the popular painter of cattle Eugène Verboeckhoven; and possibly *The Opium Smoker* by the Orientalist painter Jean Lecomte du Noüy. The cost of

these works totalled 27,300 francs, and if one adds the price paid for the Corot, which was likely to have been in excess of 10,000 francs, and for the Delacroix, probably bought for at least 20,000 francs, it is clear that in Duncan, Durand-Ruel had found a key British client whose purchasing power was on a par with the wealthiest collectors in London and Paris.

Duncan, however, was never completely reliant on dealers, and on his trips to Paris in the early 1870s customarily visited artists' studios. In 1874, at Doré's studio, he bought amongst other works *A Midsummer Night's Dream*, one of two versions of this subject that he eventually owned. Blanche Roosevelt, the famous opera singer and friend of Doré, later described this first encounter between patron and artist. After expressing his interest in other pictures, Duncan was taken by *A Midsummer Night's Dream* and made enquiries about it. Doré replied that he had decided not to sell it and "thinking to check the seeming recklessness of his unknown Maecenas for a moment, he mentioned at random 2,000 guineas, the first sum that came into his head, as the price for the picture". To Doré's surprise Duncan "immediately said, 'Will you give the refusal of it?'" Roosevelt confirmed that Duncan became Doré's "sincere friend", a "steadfast patron and ardent admirer" who eventually owned a "splendid collection" of the artist's "pictures and sketches". Roosevelt described how Duncan's "affection for the artist" was confirmed when he paid the highly successful portrait painter Charles Carolus-Duran the extremely

large sum of £1,000 for a full-length portrait of Doré, completed in 1877.

Carolus-Duran was a great admirer of Velázquez and had made his name at the Salon of 1869 where he exhibited *Woman with a Glove* (Musée du Louvre). He went on to become one of the most fashionable artists in Paris. Such was his reputation that he attracted foreign students to his studio, including John Singer Sargent. A visit to Carolus-Duran's studio was "an event for high society". It was a luxurious space, where his pictures could be seen at their best, and it was a "major sales area". As a shrewd businessman, "access to his studio was limited and he never haggled over prices", and so he would

▼ Gustave Doré, *Fairyland*, an engraving reproduced from *Cassell's Doré Gallery*, plate cxxviii, undated.

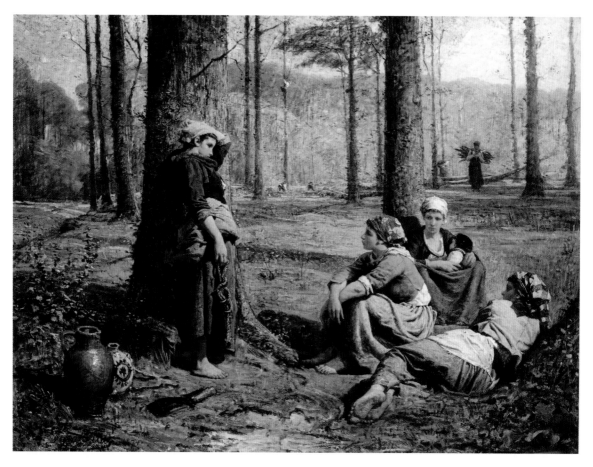

▲ Pierre Billet,
Ramasseuses de bois, 1874.
Oil on canvas, 113 × 148 cm.
Private collection.
Image thanks to the
Art Renewal Center®
www.artrenewal.org.

have welcomed Duncan's decisiveness as well as his considerable largesse. Duncan also bought from the artist *Looking Out*, a shoulder-length portrait of a fashionable lady, the type of work on which the painter's fame was based. This may well have been bought at the same time as the Doré portrait, as it was in Duncan's collection by May 1878.

Roosevelt also asserted that Doré "stayed very often at Benmore, where he was a welcome and cherished guest". There is evidence that Doré was at Benmore in the spring of 1875, and in August 1878 his stay was reported in the local press. It was during one of these visits that Duncan introduced Doré to another of his important visitors, securing a commission for a painting of Glen Massan. This was for the eminent Glasgow-born chemist James Young, whose success in distilling paraffin oil from coal enabled him to set up the first commercial oil works in the world at Bathgate in West Lothian. As well as being significant pioneers in chemistry, both Duncan and Young were drawn together through their deep admiration for David Livingstone, and both men eventually owned sculptures of the great explorer. They also shared a passion for pictures.

Early in 1874 Duncan made another significant purchase in Paris, acquiring directly from Pierre Billet

his *Ramasseuses de bois*. This painting of wood-gatherers resting in a forest doubtless appealed to Duncan on account of his interest in arboriculture. Since 1867 Billet had exhibited rustic scenes of peasant women and fishermen, winning a medal at the Salon and another at the Universal Exhibition in Vienna in 1873, exhibitions that Duncan probably attended. Also, while in his teens, Billet worked in his father's sugar refining firm, a business Duncan would have known. Duncan was certainly keen to further Billet's reputation because, not long after buying *Ramasseuses*, he lent it to that year's Salon. The following year Goupil et Cie produced a photogravure of the work which featured, together with an article by René Ménard, in *The Portfolio*, another influential Victorian journal devoted to the arts, and brought the work to an even wider audience.

Duncan did not confine himself to the purchase of French works. On 26 February 1875 he bought Philip Hermogenes Calderon's *Sylvia* for £150 from the Glasgow Institute exhibition. Calderon was a British painter who had achieved acclaim in 1857 when he exhibited his *Broken Vows* (Tate Britain) in a style inspired by the Pre-Raphaelites. Duncan also showed a taste for German and Austrian art. One of his most important acquisitions was the colossal *The Triumph of Ariadne* by Hans Makart, exhibited in the artist's Vienna studio in July 1875, which Duncan bought directly from the artist the same year.

By 1875 Makart had achieved a certain celebrity in Vienna, and his atelier at the Gusshausstraße, provided for him by Prince von Hohenlohe, became a sort of exclusive salon attracting the nobility and bourgeoisie alike. Cosima Wagner, wife of the

▼ Hans Makart,
The Triumph of Ariadne,
1874. Oil on canvas,
476 × 784 cm.
Upper Belvedere, Vienna.
Image thanks to the
Art Renewal Center®
www.artrenewal.org.

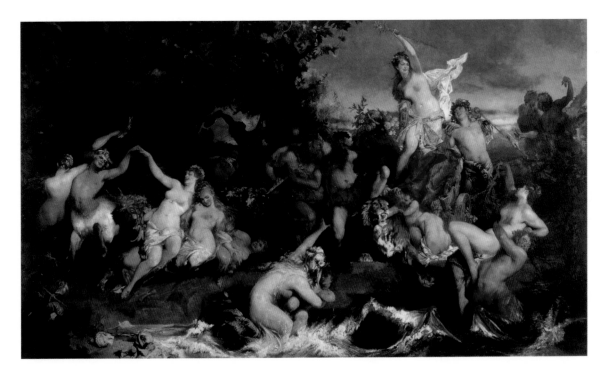

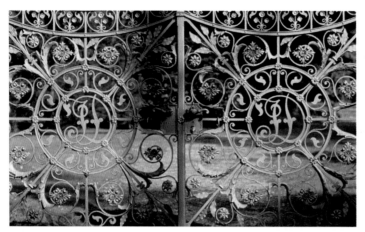

▲ Detail from the golden gates at Benmore, commissioned by Duncan from a Berlin firm in the 1870s and exhibited at the 1878 Paris Universal Exhibition. Image: RBGE Archive.

great composer, described it as a "wonder of decorative beauty". Makart became known as an "artist prince" (*Malerfürst*), whose passion for vast canvases of mythological and allegorical subject matter, and sumptuous use of colour, won him the flattering epithet of the "Austrian Rubens". *The Triumph of Ariadne* is important for reasons other than its intrinsic merit. In buying this *grande machine* Duncan appears quite unlike the typical bourgeois collector, who would largely favour small-scale cabinet pictures for his interior, and demonstrated that he had the means to purchase canvases recognised in France and Britain as being too large and expensive for most collectors. As Duncan could not have accommodated the eight-metre-long *The Triumph of Ariadne* at any of his residences, this may have been the first indication that he was planning to build a gallery of suitable size and grandeur to display such works.

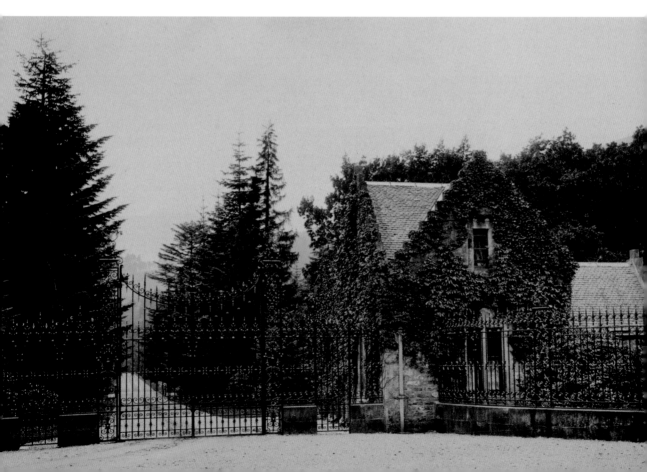

Through his attendance at international exhibitions, Duncan was well aware of the leading European manufacturers of applied art. At some point in the early 1870s he commissioned a Berlin firm to design and make a pair of fine wrought-iron gates - the golden gates, as they are now known - for the Paris Universal Exhibition of 1878. He brought these back to Benmore where they were erected at the Glen Massan entrance to the estate, complete with the marble pillars that had been carved by local stonemasons in 1873. He also installed a German-designed Carrara marble fountain at a cost of £1,500. In 1874 he further embellished his estate, adding to the east entrance an elegant wrought-iron gate and railings, apparently "specially manufactured in Paris at great expense".

The year 1875 marked the beginning of a period of increased exposure for Duncan's pictures through loans to important exhibitions throughout Europe. In February he lent Doré's *A Midsummer Night's Dream* to the Royal Glasgow Institute of Fine Arts, the first of many of his French paintings to be shown there. The following year Duncan lent Corot's *La toilette* to the Institute, the first time the picture had been shown in Britain, but the opportunity of reporting on Corot's masterpiece was missed by journalists in Edinburgh and Glasgow. *The Scotsman* ignored *La toilette* completely, praising instead Billet's *Ramasseuses* as "one of the most remarkable works in the exhibition", while the writer for the *Glasgow Herald*, unable perhaps to accommodate the bold, confrontational gaze of the nude which dominates the picture, wrote disparagingly that it occupied "a good deal of space, which ladies

▲ **Left:** German designed Carrara marble fountain in the greenhouse c.1890s, Benmore Formal Garden. This is how it would have looked in Duncan's time. Photo: Courtesy of David Younger.

Right: German designed Carrara marble fountain at Benmore after the dismantling of the greenhouse. Photo: Courtesy of David Younger.

◄ The wrought-iron gates and railings in situ at the East Gate entrance to the Benmore Estate in the 1890s. The gates and railings were manufactured in Paris in 1874. Photo: Courtesy of David Younger.

▶ William Holl, after
Sir Henry Raeburn,
Sir David Brewster, 1847.
Line and stipple
engraving on paper
11.43 × 8.89 cm.
Scottish National
Portrait Gallery
(SP VI 5.2).

especially would prefer had been better filled up".

This type of prudish Victorian sentiment in the face of the female nude was the same kind satirised by artists in France at an earlier date. In 1864 Honoré Daumier drew two women turning away in shock from the Salon's Venuses on the wall behind them. A contemporary humorous account of Duncan's collection opined that it was one which would "drive Mr Horseley [sic], R. A., into a frenzy, and the British matron into permanent hysterics". The writer was referring to John Calcott Horsley, a Victorian academic painter and a deeply religious man who opposed the practice of female models posing naked for artists. In May 1885 he wrote a piece for *The Times* entitled "A woman's plea" and signed it "A British matron".

The *Christian Leader*, a periodical that featured favourable articles on Duncan and his collection in 1882 and 1883, also represented views

completely opposed to French art and intolerant of its collectors. In 1882 one writer described the French School of painting as "meretricious and in bad taste, as well as lascivious in character"; still another was deeply suspicious of the morality of picture collectors, describing them as fatuous. We do not know how Duncan reconciled his Free Church principles with the sensual imagery of his French Salon pictures, but these constituted only one facet of a collection eventually numbering over 300 works, which we know from the article in *Fairplay* was designed by Duncan to be "representative" of major schools.

Although the same writer for the *Christian Leader* also saw collectors as "frivolous people" who competed "wildly" at Christie's, Duncan realised that in an era notorious for its many forgeries of old masters, a collector could acquire quality works with known provenances from important sales at Christie's. However, Duncan's reserve and desire to remain anonymous led him to avoid the auctions, using instead the London dealer Gladwell as an intermediary.

Duncan's interest in old masters is first evidenced by his purchase of *The Fortune Teller* by Frans van Mieris and *A Sunny River Scene* by Adam Pynacker from one of the most important sales of old masters to take place in the 1870s: the Wynn Ellis sale at Christie's in May 1876.

In 1877 Duncan also acquired from Christie's Raeburn's celebrated portrait of Sir Walter Scott, a writer whom Duncan admired, and the first of three paintings of Scott that he purchased.

▶ Sir Henry Raeburn,
Sir Walter Scott, 1822.
Oil on canvas,
76.2 × 63.5 cm.
Scottish National Portrait
Gallery (PG 1286).

▶ **Left:** Théodore Rousseau, *Morning*, 1865. 200 × 136 cm. Location unknown. Image taken from David Croal Thomson, *The Barbizon School*, London, 1891.

Right: Théodore Rousseau, *Evening*, 1865. 200 × 136 cm. Location unknown. Image taken from David Croal Thomson, *The Barbizon School*, London, 1891.

▼ Daubigny, Charles François (1817–1878): *The Banks of the Oise*, 1863. New York, Metropolitan Museum of Art. Oil on wood, 14 3/4 × 26 3/8; (37.5 × 67 cm). Bequest of Benjamin Altman, 1913 (14.40.815) © 2010. Image copyright The Metropolitan Museum of Art/ Art Resource/Scala, Florence.

At the same sale Duncan also bought Raeburn's portrait of Sir David Brewster, his choice of sitter having additional, personal relevance.

As well as being an eminent scientist, Brewster had helped to found the British Association for the Advancement of Science in 1831, in which Duncan took great interest. In 1877 similarly personal and patriotic sentiments led to the purchase of Landseer's *Sir Walter Scott in the Rhymer's*

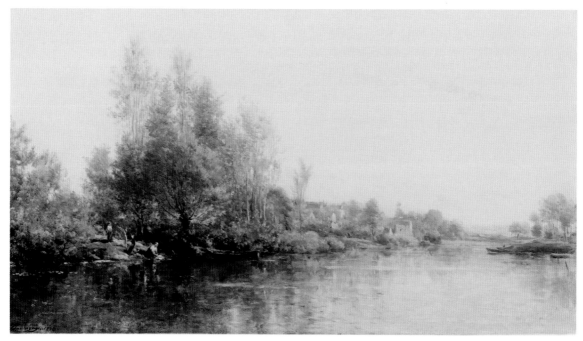

Glen, a painting that was one of the most sought after in London and caused a stir among potential buyers. *The Times* reported that a "very spirited contest arose over this interesting picture, and it brought the large sum of £3,202 10s … purchased for a gentleman in Scotland". Devotees of art in Britain would have seen this picture as one of Duncan's most significant acquisitions. It also confirmed that Duncan's purchasing power was equal to the wealthiest collectors in the country.

Between February 1876 and May 1878, Duncan bought six pictures from Goupil's Paris Gallery at the Place de l'Opéra. Traditionally, the firm had promoted pictures by established academics such as Delaroche and Gérôme, but in the 1870s it began to stock work by Barbizon painters such as Diaz and Théodore Rousseau. As Duncan's taste encompassed both the academic and the romantic schools, he was naturally drawn to Goupil. He made his first purchase there in February 1876 when he paid 3,000 francs for *Venus Carrying Cupid* by Diaz. In April of the following year he bought *Le Mont Chauvet, Forêt de Fontainebleau* by Théodore Rousseau – one of at least three works by this artist that Duncan owned – and *La Cinquantaine* by the Italian historical and genre painter Cesare-Auguste Detti, who was then well known for his costume pictures. In May Duncan acquired a portrait of a young boy by Jean-Baptiste Greuze, the 18th-century French master of genre scenes, and in June *Two*

Greyhounds at a Fountain by Gérôme. One year later Duncan acquired two untitled works from Goupil, one by Diaz and one by Philippe Rousseau, who had achieved great success at the Salon with his still-lifes.

Shortly after buying them, Duncan was eager to exhibit his latest acquisitions. To the Salon of 1877 he lent *La Cinquantaine* and to the Royal Glasgow Institute of Fine Arts in 1878 *Le Mont Chauvet, Forêt de Fontainebleau* as well as two pictures by Meissonier: *The Captain (Un Officier)* and *The Standard Bearer*, which have not been traced. Meissonier was one of the

▼ Ludwig Knaus, *Springtime*, 1868. Oil on canvas, 66 × 50 cm. Private Collection. Image thanks to the Art Renewal Center® www.artrenewal.org.

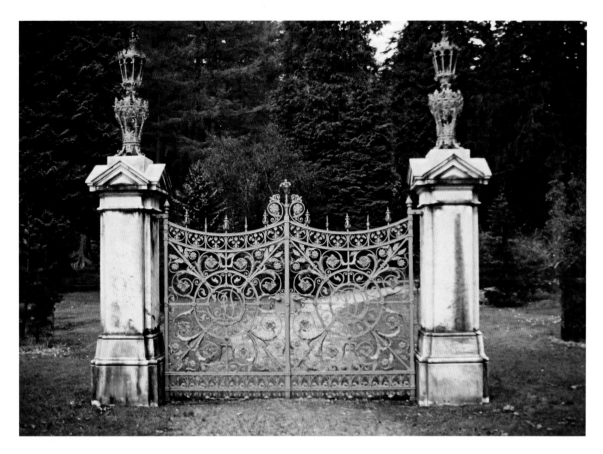

▲ The golden gates
at Benmore.
Photo: Andrew M. Watson.

most successful and popular artists of his era and would have added great prestige to Duncan's collection. The Meissoniers, especially *The Standard Bearer*, drew warm praise from a critic for the *North British Daily Mail*, who described "the colour and the finish in every part [as] being marvellous".

In May 1878 Duncan sat on the Acting Committee that organised an exhibition in the Glasgow Corporation Galleries in aid of the funds of the Royal Infirmary, a major exhibition devoted entirely to modern paintings "chosen exclusively from the collections of gentlemen living in Glasgow and the Western districts more immediately in connection with that City". The 11 works that Duncan lent represented the modern schools of France, Germany, the Netherlands and Italy, including Charles-François Daubigny's *The Banks of the Oise*, Ludwig Knaus's *Springtime*, Josef Israels's *The Fisherman* and Tito Conti's *After Dinner*. The esteem in which Duncan's Glasgow contemporaries held him was acknowledged that same year. At its annual meeting on 4 November 1878 the Council of the Royal Glasgow Institute of Fine Arts recommended Duncan for the honorary post of Vice President, a position he held until 1887.

It is almost certain that Duncan visited the Paris Universal Exhibition in 1878. This was an important World Fair, celebrating France's

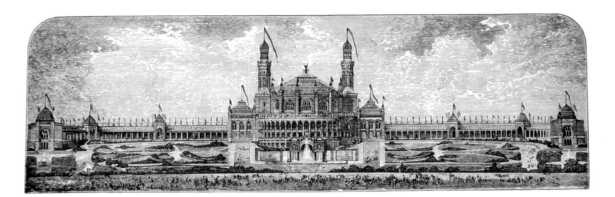

economic recovery after the Franco-Prussian War, and it proved a resounding success. Among many notable exhibits was Alexander Graham Bell's telephone. Duncan proudly exhibited livestock, his golden gates, as well as five pictures from his collection. Carolus-Duran's portrait of Doré was seen publicly for the first time, and Antoine Vollon's *Femme du Pollet, à Dieppe* attracted the attention of the influential novelist and critic Émile Zola in his review of the exhibition. Doré's *L'Aurore dans les Alpes*, a picture that Duncan later purchased, was also on show. The agricultural section of the exhibition similarly put Duncan in the spotlight. His prize bull from the Benmore estate so impressed Bonheur that she asked his permission to paint it, a request that was duly granted.

▲ *The Trocadéro Building, Paris Universal Exhibition*, 1878. Engraving. Image taken from *Magazine of Art*, 1878.

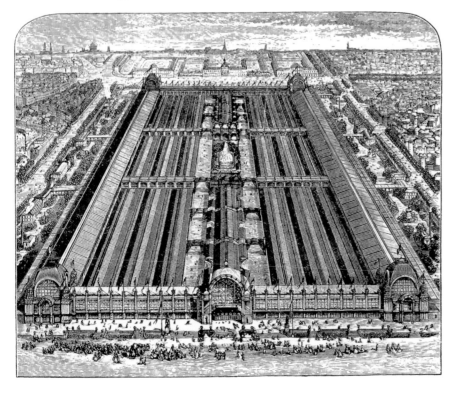

◄ *The Buildings of the Champ de Mars, Paris Universal Exhibition,* 1878. Engraving. Image taken from *Magazine of Art*, 1878.

Duncan's Salon: Benmore Picture Gallery

Duncan's interest in French Salon pieces continued to be a feature of his collecting. In 1879 he bought Henner's *Églogue* and Lefèbvre's *Diana Surprised*, both of which were shown at the Salon and were destined for his Benmore gallery. According to one journalist, the painting by Lefèbvre was one of the most important to be exhibited that year, its subject having been popularised by engravings. The French state reputedly initiated negotiations for its purchase, proposing the sum of 10,000 francs. Meanwhile, Duncan, who visited the painter in his studio at 5 rue de la Bruyère, offered £1,500 (37,000 francs), which Lefèbvre, who had been holding out for 12,000 francs, unsurprisingly accepted. Such works were difficult to sell privately since there were very few collectors with sufficient

▼ Photograph of Benmore House with Duncan's picture gallery to the right, c. 1889–1890. Courtesy of David Younger.

space to hang them. Accordingly in 1879 work began on Duncan's estate to erect a picture gallery suitable for large-scale paintings. This may also have been the date of Duncan's purchase of Delacroix's *The Death of Sardanapalus*, undoubtedly his greatest acquisition.

Today, *Sardanapalus*, which hangs in the Louvre, is universally recognised as one of the great masterpieces of the 19th century. Ever since it was first exhibited at the Salon in 1827, the picture had courted controversy. Inspired by the finale of Byron's eponymous work (1821), it depicts the Assyrian King, faced with defeat by insurrectionary forces, who orders the destruction of his concubines and horses in a scene of orgiastic violence. The chilling nature of the work is intensified by the contrast between the violence enacted and the impassivity of Sardanapalus himself. At its initial

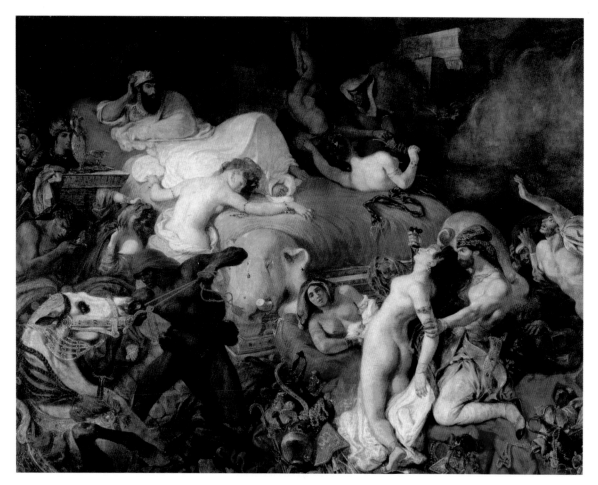

showing, Delacroix's treatment
of the subject was condemned
by most critics as indulgent and lurid.
The French Minister of Fine Arts
warned that continued production
of works like this would jeopardise
Delacroix's chances of obtaining
further state patronage. *Sardanapalus*
then remained unsold for almost
20 years until the Parisian collector
John Wilson bought it in 1846.
It stayed in his family collection
until Durand-Ruel bought it from
his son Charles in 1873. Early that
year the *Art Journal* announced that
Durand-Ruel proposed "to bring
it to England, and exhibit it",

which, in view of the hostile stance
of British artists and critics towards
nudity and French art in general,
was a risky venture. Surprisingly,
many press and scholarly reviews were
largely positive. As M. M. Heaton
wrote in the *Academy*, "the apparition
of such a picture as this in a modern
gallery where we are only accustomed
to find faithful landscapes and
sentimental domestic genre subjects
is perfectly startling. It is like an
opium dream in its evil beauty and
splendid horror." One wonders
what effect it had on those with
religious and puritanical sensibilities
like Horsley.

▲ Eugène Delacroix,
The Death of Sardanapalus,
1827. Oil on canvas,
392 × 496 cm. Musée du
Louvre (RF2346).
Image thanks to the
Art Renewal Center®
www.artrenewal.org.

▼ Jean-François Millet,
The Sheepshearers, c. 1857–1861.
Oil on canvas, 41.2 × 28.5 cm.
The Art Institute of Chicago,
Potter Palmer Collection
(1922.417).
Photography © The Art
Institute of Chicago.

Although it is known that Durand-Ruel sold *Sardanapalus* to Duncan, there is no mention of it in his ledgers. In his published memoirs he recalled being happy to have sold the painting for 60,000 francs some time between 1874 and 1879, but gave no precise date. It seems certain that Duncan cannot have bought the picture before 1878 as Durand-Ruel exhibited it in his Paris gallery that year. On that occasion, the lender of the work was Fremyn, who

had business connections with Durand-Ruel. It is not established, however, if Fremyn (who was an established collector of Delacroix) owned the painting, and his name might have been linked with the picture, in much the same way as that of Edwards was used in 1870, to improve the chances of selling it. Contemporary accounts mention Duncan as the only purchaser. According to a journalist for the *Dunoon Observer and Argyllshire Standard*, Durand-Ruel could not sell it but eventually "induced" Duncan "to take it off his hands at 46,000 francs". This tallies with an account in an unidentified Paris newspaper. The purchase most probably occurred between 1878 and 1880, as the dealer's ledgers, which are complete between 1880 and 1890, do not list the sale of the work.

Duncan continued to add to his collection of Barbizon pictures, which was one of the finest in Britain at that time. In 1880 he lent a landscape by Constant Troyon and Jean-François Millet's *The Sheepshearers* to the Glasgow Institute's annual exhibition. Millet's paintings of peasants were generally popular with Scottish collectors, but owing to Duncan's interest in rearing cattle and sheep, this was a more personal choice on his part.

In September 1881 Duncan decided to give the public a unique opportunity of seeing his pictures. On 24 September the *Dunoon Observer and Argyllshire Standard* announced, "The famous Picture Gallery adjoining Benmore House is, through the kindness of Mr Duncan now open to visitors." *Sardanapalus, The Triumph of Ariadne* and *Diana Surprised*, together

with a host of other significant works, were shown publicly in Scotland for the first time, an event all the more important as Delacroix's works had never before been exhibited in Scotland.

According to one contemporary report, the picture gallery in question "was 157 feet in length, 64 feet, 6 inches in breadth, and 60 feet in height, the roof being of glass, spanned by iron girders". It cost Duncan between £7,000 and £8,000 to build. In conceiving the gallery on such a grand scale Duncan may have wanted to evoke an atmosphere similar to that experienced in the huge top-lit installations erected for the Industrial exhibitions. The architectural plans have not survived but Thomson is most likely to have carried out the design. As Duncan's principal architect, he had experience of this type of work. What

is more, in 1867, at the behest of the Glasgow Corporation, Thomson had converted part of the McLellan Gallery and Warehouse in Sauchiehall Street into a large picture gallery in which temporary exhibitions were held.

As evidence of its popularity, Duncan's gallery attracted 4,000 visitors during the first year it was open. Visitors were aided by publications such as *Martin's Guide to Dunoon* (1881),

▲ The Art Treasures Exhibition, Manchester, 1857 (interior). Image taken from the *Illustrated London News*, 1857.

◀ Advert for Benmore picture gallery, 15 June 1882. Image taken from the *Dunoon Observer and Argyllshire Standard*. Photo: Archie Fergusson. © The *Dunoon Observer and Argyllshire Standard*.

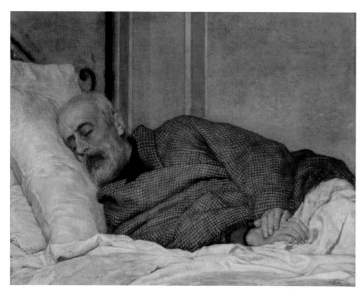

▲ Silvestro Lega, *The Dying Mazzini* (*Mazzini morente*), 1873. Oil on canvas, 76.5 × 100.3 cm. Museum of Art, Rhode Island School of Design. Helen M. Danforth Acquisition Fund. Photography by Erik Gould, courtesy of the Museum of Art, Rhode Island School of Design, Providence.

▶ Camille Corot, *Le Passage du gué, le soir*, c. 1868. Oil on canvas, 99 × 135 cm. Musée des Beaux-Arts de Rennes, Réunion des musées nationaux (DO.70.6.1; RF1791). © MBA, Rennes, Dist RMN/ Adélaïde Beaudoin.

which, in directing its readers to Duncan's "beautiful residence", stated that "permission may be asked at the lodge to obtain a view of the mansion-house, and parties very desirous of obtaining a view of the picture gallery, one of the richest private collections to be found in Scotland, may hand in their card". A writer for the *Christian Leader*, one more favourably disposed to picture collectors than some of his fellow writers for the journal, was "exceedingly gratified with the choice pictures" which adorned the walls and drew attention to how the glass roof threw an "abundance of light upon the collection", creating pleasure "of the most refined character".

The same writer also acknowledged Duncan's generosity and unique public spirit by opening his gallery to "all who care to accept his invitation". The article concluded with typical Victorian idealism: "If such generous acts were more general it would help to overthrow many of the barriers between the opulent and the poor." In fact, Duncan's approach was exceptionally

public-spirited. Few collectors of Duncan's generation allowed members of the public into their private residences to see their collections.

Duncan's gallery opened again in June 1882, this time with a special coach service from Dunoon and Sandbank, which was advertised in the local press. Passengers were taken through the golden gates at the South Lodge, past the fernery, before arriving at Benmore mansion. One critic was inspired to extol the "magnificent collection of paintings and statuary, numbering fully 300 specimens", highlighting Landseer's *Sir Walter Scott in the Rhymer's Glen* and Silvestro Lega's *The Dying Mazzini* for particular praise, as well as the "remarkably good" paintings by "Miss Rosa Bonheur, the celebrated French artist". None of the more challenging French pictures was mentioned. The following extract evokes the gallery's appearance:

"Here and there throughout the large hall some handsome pot plants are placed, and also cushioned seats for visitors to rest upon. A fine specimen of the New Zealand tree fern occupies the centre of the floor, and under its spreading foliage, the visitors may recline, and at the same time admire the numerous canvases with which the walls are covered. Ranged along the floor are well-executed busts of Queen Victoria, the Princess of Wales, Mr Spurgeon, the well-known preacher of the Metropolitan Tabernacle (at present on a visit at Benmore House), Mr Gladstone, the Prime Minister, the Right Hon. John Bright, Lord Brougham, the Prince Imperial, &c."

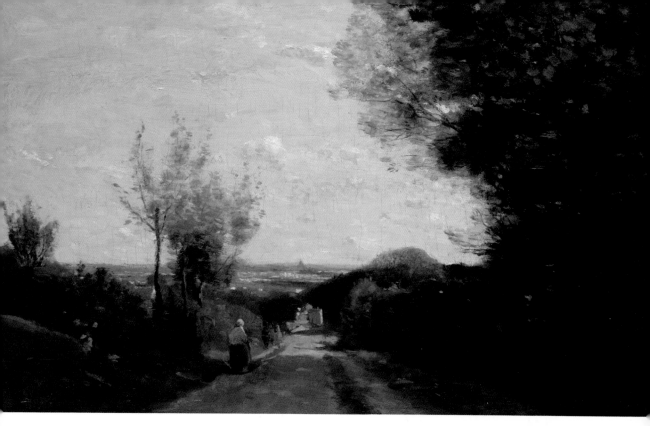

In addition to John Adams-Acton's busts of Spurgeon (1875) and Queen Victoria, visitors would also have seen Hiram Powers's *Boy with a Shell*, one of several versions of this theme that the American sculptor made in the 1840s, revealing Duncan's taste for neo-classical sculpture. By the summer of 1882 visitors would also have seen more recent purchases including *A Boat at Sea* by Millet, which had been exhibited in February at the Royal Glasgow Institute of Fine Arts.

In 1883 the gallery attracted international attention. One visitor was a correspondent for *The New York Observer* who, in an article published that summer, made mention of the gallery and drew attention to the Meissoniers. He would not have been able to see 11 of Duncan's pictures, however, as in July these were on loan to the Munich International Exhibition. These included Doré's *A Midsummer Night's Dream*, Henner's *Églogue* and what could have been *Environs of Paris* or Corot's *Le Passage du gué*, both impressive canvasses by the great French landscapist that were likely to have been purchased from Durand-Ruel. Duncan was by now clearly recognised throughout Europe as a major collector of French art.

▲ Corot, Jean Baptiste Camille (1796–1875): *The Environs of Paris*, 1860s. New York, Metropolitan Museum of Art. Oil on wood, 13 1/2 × 20 1/4; (34.3 × 51.4 cm). Theodore M. Davis Collection, Bequest of Theodore M. Davis, 1915 (30.95.272) © 2010. Image copyright The Metropolitan Museum of Art/ Art Resource/Scala, Florence.

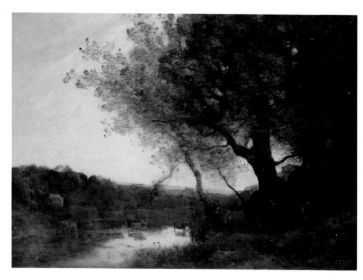

Three new paintings that added to the prestige of Duncan's collection were bought in 1883 from Durand-Ruel. These were Bouguereau's *La nuit*, Eugène Boudin's *Soleil couchant* and Renoir's *The Bay of Naples (Morning)*. The Renoir, so markedly different in colour and tonality from Duncan's other French paintings, is a surprising purchase, but it proved to be one of Duncan's most significant, as it made him the first Scottish collector to buy an Impressionist work. As in so many of his other ventures, Duncan's discernment and foresight enabled him to stay well ahead of his contemporaries, in this case anticipating avid interest in Impressionist art in Scotland. It would be another nine years before the Glasgow collector Thomas Glen Arthur bought from the dealer Alexander Reid Edgar Degas's *At the Milliner's* of 1882 (Metropolitan Museum of Art, New York). Prior to this, only four British collectors (all English) are known to have been interested in acquiring Impressionist paintings. Duncan occupies an important place in the history of British collecting of Impressionist works, joining the pioneering group of Louis Huth, Henry Hill, Constantine Alexander Ionides and Samuel Barlow.

In the 1870s they and Duncan had little opportunity to see Renoir's work. Between 1872 and 1874 Durand-Ruel exhibited only three of his pictures in London, and it was not until late March 1883 that Duncan could properly assess the artist at a show devoted entirely to Renoir which the dealer organised in the Boulevard de la Madeleine. Seventy pictures were shown, one of which was *The Bay of Naples*. French critics –

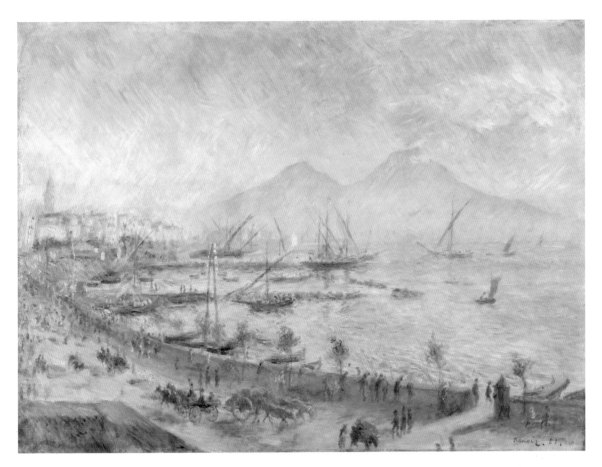

even those who were devotees of Impressionism – condemned Renoir as a landscape painter, citing *The Bay of Naples* in justification.

As Renoir was Durand-Ruel's "great favourite", he must have been especially pleased to sell *The Bay of Naples* to a collector who, in similar fashion to his purchase of *Sardanapalus*, was again bold and decisive, not influenced by fashion and undeterred by controversy. The significance of Duncan's acquisition is underscored by the fact that it was (so far as we know) the only Renoir bought by a British collector in the 19th century.

A year after he purchased his Renoir, Duncan lent *The Captain* to an exhibition devoted entirely to Meissonier in the

galleries of Georges Petit. This was one of a series of shows organised by the charitable organisation *L'Hospitalité de Nuit*, founded in 1878 to help the homeless and destitute of Paris. It is not surprising that Duncan supported such a venture, taking his place among an elite group of collectors that included Sir Richard Wallace. Duncan was one of the few collectors wealthy enough to afford Meissonier's pictures. Described as the "most honoured and successful artist of the nineteenth century", his canvases sold for vast sums. Duncan's two paintings, both relatively small, were valued in 1883 at £6,000, making them and his Landseer the most valuable pictures in the collection.

▲ Renoir, Pierre Auguste (1841-1919): *The Bay of Naples*, 1881. New York, Metropolitan Museum of Art. Oil on canvas, 23 1/2 × 32 in. (59.7 × 81.3 cm). Inscribed: Signed and dated (lower right): Renoir. 81. Bequest of Julia W. Emmons, 1956. (56.135.8) © 2010. Image copyright The Metropolitan Museum of Art/ Art Resource/Scala, Florence.

◀ William-Adolphe Bouguereau, *I a nuit* (*Night*), 1883. Oil on canvas, 208.3 × 107.3 cm. Hillwood Estate, Museum & Gardens, Bequest of Marjorie Merriweather Post, 1973 (51.12). Photo by Edward Owen.

▲ Velazquez (1599-1660), (Workshop): *Mariana of Austria (1634–1696)*, Queen of Spain, 1660. New York, Metropolitan Museum of Art. Oil on canvas, 32 1/4 × 39 1/2 in. (81.9 × 100.3 cm). Marquand Collection, Gift of Henry G. Marquand, 1889 (89.15.18). © 2010. Image copyright The Metropolitan Museum of Art/ Art Resource/Scala, Florence.

Another work of particular note that was in Duncan's collection by 1885 was Hendrik van Lint's *View of the Palazzo Caprarole*, one of his important old master paintings that had been auctioned at the Hamilton Palace sale in 1882. With the exception of this picture and those from the Wynn Ellis collection, few of Duncan's old masters had recorded provenances and are therefore now difficult to trace. We know, however, that he owned Dutch and Flemish works by Adam Pynacker, Jan van Goyen,

Philips Wouverman, Adriaen van de Velde, David Teniers the Younger and Adriaen Brouwer. Spanish art also proved popular with Glasgow collectors. At some point Duncan bought one of Goya's full-length portraits of the future Ferdinand VII, and a workshop copy of Velázquez's *Mariana of Austria (1634–1696), Queen of Spain*.

Among Duncan's last acquisitions were Otto Sinding's *Funeral at Lofoten*, John Watson Gordon's *Portrait of Sir Walter Scott* and *Thomas de Quincey*

and Sir John Steell's bust of Robert Burns, in all likelihood similar to the celebrated work unveiled at Westminster Abbey in 1885. Such was the stature of the collection by this date that Roosevelt, in her book on Doré published in 1885, acknowledged Duncan as having "one of the finest galleries in Europe filled with the choicest works of ancient and modern art". It was at this juncture that Duncan was given the opportunity of further enhancing the reputation of his collection.

In 1885 a group of Edinburgh merchants sought to promote trade in the Scottish capital along the lines of the Great Exhibition in London of 1851 and began planning the Edinburgh International Exhibition of Science, Industry and Art, which opened in May 1886 – Scotland's first World Fair. Duncan, who had gained so much experience of industrial exhibitions and had previously supported the Edinburgh International Forestry Exhibition in 1884, lent money to the exhibition's guarantee fund. As one of the most generous owners of pictures in Europe, he must have looked forward to the opportunity of lending works to such an important Scottish show.

▲ Sir John Steell, bust of Burns in Westminster Abbey. Image: © Dean and Chapter of Westminster.

◄ **Left:** Sir John Watson Gordon, *Portrait of Sir Walter Scott*, c. 1831–1835. Oil on canvas, 76.2 × 63.5 cm. Philadelphia Museum of Art, The John Howard McFadden Collection, 1928 (M1928-1-42).

Right: Sir John Watson Gordon, *Thomas de Quincey, 1785–1859*, 1846. Oil on canvas, 76.2 × 63.5 cm. Scottish National Portrait Gallery (PG 1116).

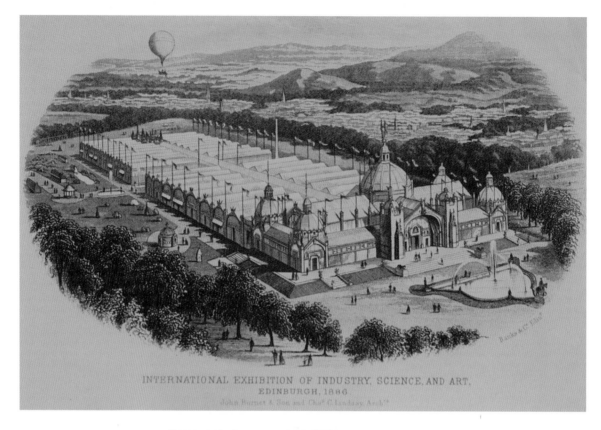

INTERNATIONAL EXHIBITION OF INDUSTRY, SCIENCE, AND ART,
EDINBURGH, 1886.
John Burnet & Son and Thos C Lindsay, Archts

▲ Engraving of building
erected in the Meadows for
the Edinburgh International
Exhibition of Industry, Science
and Art, 1886. Edinburgh City
Archives Acc. 423. By kind
permission of David Salmon.

▶ William Brodie,
David Livingstone (marble).
By kind permission of
Shirley Page.

Large temporary buildings were
erected in Edinburgh's Meadows and,
when the exhibition opened in May, it
included a fine-art section that featured
1,725 works. Duncan contributed a
full-length statue of David Livingstone
by the acclaimed Scottish sculptor
William Brodie. Hailed as one of the
most important exhibitions of art
yet to have taken place in Scotland,
the international dimension of the
paintings section would not have
been possible without the loan of
French and Dutch paintings organised
by the Edinburgh merchant Robert
Thomas Hamilton Bruce. In 1885
Bruce set about the task of securing
pictures from Scots collectors north
and south of the border, amassing a
significant number of Barbizon and

Hague School paintings. Particularly appealing to Bruce would have been the very high quality and scope of the French pictures in Duncan's collection, which represented every major development in French 19th-century painting from Romanticism to Impressionism, including the major Salon painters. It was unparalleled in Scotland. No other Scottish merchant collector could lend works by Delacroix, whose *Sardanapalus* took centre stage.

Yet Duncan's collection, so well known in Europe, was destined never to enjoy a similar reputation in Scotland. In the month before the Edinburgh International Exhibition opened, on 3 April 1886, it was reported in the Argyllshire press that "a rumour is current to the effect that quite a number of the Benmore collection of paintings are being packed for transmission to London". In May some of Duncan's most prized possessions – *Sir Walter Scott in the Rhymer's Glen*, *Sir David Brewster* and *La toilette* – had already been sold at auctions in London and Paris. This Edinburgh show, which should have been a lasting testament to Duncan's prominence as one of the greatest collectors of his generation, was instead bereft of his pictures. By a twist of fate, economic factors in the sugar trade, of which he was well aware, had become critical in early 1886, forcing Duncan to close his Silvertown refinery, and sell his Benmore estate and most of his art collection.

Conclusion

Throughout the 1870s there was a growing awareness in Britain that its industrial Golden Age was in serious decline. The textile industry, on which Britain's prosperity was largely based, had diminished. It was increasingly being challenged by foreign competitors who benefited from British exports in textile engineering. Even in growth industries such as steel, Britain never enjoyed the same dominance it had in textiles. By the 1880s Germany's rapidly advancing steel trade was protected by tariffs on imports. In the sugar trade too, Germany was at the forefront of the so-called bounty system, which provided subsidies for its manufacturers, enabling them to export cheap sugar to foreign rivals. As a supporter of free trade, Duncan strongly opposed protectionist policies and, as Chairman of the Sugar Refiners' Committee, he was an outspoken critic of the bounty system, frequently expressing his views in *The Times*.

In a letter to *The Times* in 1879 Duncan described some movement on the part of France, Holland and Belgium to abolish the bounty system, which had such an "injurious effect" on British and colonial refiners. Only a year later he reported ominously that, owing to the large bounty admitted by the French government, refiners in France were "able to sell in our markets considerably below cost price" and that "the effect of such a bounty is inevitable". This portentous concluding sentence, implying that

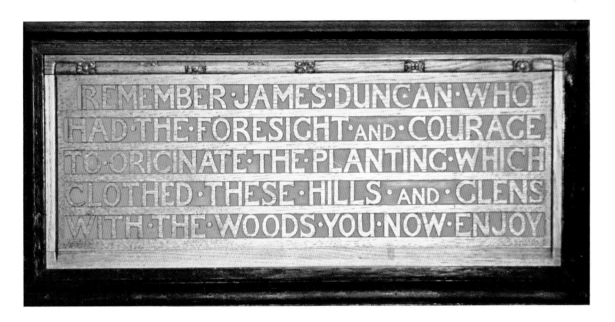

REMEMBER·JAMES·DUNCAN·WHO
HAD·THE·FORESIGHT·AND·COURAGE
TO·ORIGINATE·THE·PLANTING·WHICH
CLOTHED·THESE·HILLS·AND·GLENS
WITH·THE·WOODS·YOU·NOW·ENJOY

▲ Carving in Puck's Hut
in the Formal Garden at
Benmore Botanic Garden.
Photo: Andrew M. Watson.

little could be done to prevent the disastrous effect of the bounty system on the British sugar industry, is the first indication that Duncan foresaw the demise of his business empire.

In 1883 there were already signs that Duncan's financial situation was unstable when he decided to let Benmore House for a five-year period. He also began to sell various plots of land. Although the gallery opened for the season in 1884, this was the last time the whole collection would be viewed by the public. After 1883 Duncan never stayed at Benmore again. Faced with the problem of the crippling bounties and a further downturn in the economy (which led in 1885 to the appointment of a Royal Commission on the Depression in Trade and Industry) Duncan was forced to take drastic measures to avoid bankruptcy. By the beginning of 1886 he realised that he would have to sell his Silvertown refinery and all his most valuable possessions, starting with his pictures. On 9 November 1886, Duncan wrote a poignant letter from London to the Council of the Royal Glasgow Institute of Fine Arts. This rare document, recorded in the Institute's minute books, is Duncan's only known letter in which he makes clear that he was intending to sell many of his paintings:

"As I am not likely to be in Scotland in January 1887, [I] will not be present at the Banquet. I should prefer the Institute to remove my name as a Vice-President. Most of my pictures will be sold and I will not be in a position at present to lend pictures. I will still take a lively interest in your Exhibition and if you wish any information at any time I will be most happy to give it to you…"

The Council of the Glasgow Institute expressed "great regret at this intimation of Mr Duncan's resignation". Although Duncan never again held such a prominent role in the

◀ Puck's Hut,
Benmore Botanic Garden.
Photo: RBGE/Lynsey Wilson.

▲ William Brodie's *David Livingstone* in the entrance hall of Strone House, Strone, c. early 1900s. Duncan's sister Mary Moubray lived at Strone House and was given the sculpture by Duncan some time after he sold Benmore. By kind permission of Shirley Page.

organisation, he nonetheless remained a life member.

Already by April of that year, part of Duncan's collection was packaged and ready for transportation. On 12 April 1886 he sent 17 of his pictures to the London branch of Boussod, Valadon et Cie, formerly Goupil et Cie, where they were received by its manager, the Scottish dealer and expert on the Barbizon School, David Croal Thomson. The paintings were then despatched to Paris where Boussod, Valadon's Paris manager, Theo Van Gogh, sold them at considerable profit.

Within just a few days leading Parisian collectors had purchased many of these important pictures. Victor Défosses bought four works, including Corot's *La toilette* and Rousseau's *Le Mont Chauvet, Forêt de Fontainebleau*. The jeweller Henri Vever acquired Corot's *Le Passage du gué* and Daubigny's *The Banks of the Oise*; while Rousseau's *Allée sous bois*, Daubigny's *Pont et village* and Millet's *The Sheepshearers* went to the banker Henri Poidatz. In May more of Duncan's pictures were shown at 4 rue Meyerbeer, Paris. *The Bay of Naples* attracted the New York-based Scottish dealer James Smith Inglis, who bought it some time between 1886 and 1888.

In July 1887 Christie's auctioned 65 of Duncan's works, including modern pictures and old masters. In 1889 50 paintings were auctioned at Foster's, and on 15 April 33 of Duncan's large-scale French works, including *Sardanapalus*, were auctioned in Paris at the Hôtel Drouot. Surprisingly, given the importance of the sale, no major British newspaper or periodical outside Argyllshire appears to have reviewed it. On 27 April 1889 the *Dunoon Observer and Argyllshire Standard* reported that "a considerable portion of the collection has been disposed of privately during the last two years", and went on to say that "there still remained a number of important pictures, too large for the majority of private purchasers, and as many of them were by French artists it was concluded that Paris would probably be the best market for them".

However, the Paris art market was depressed and Duncan made considerable losses on his pictures. Henner's *Églogue* sold for almost

half of what he had paid for it. Described by *Le Figaro* as a "capital work", it went to the Parisian dealer and "confrère" of Durand-Ruel, Étienne-François Haro, for 12,400 francs, who also bought *Sardanapalus* for 34,000 francs.

On 12 October that year, it was announced in the Argyllshire press that "The estate of Benmore, at the head of Holy Loch, belonging to Mr James Duncan, has been purchased by Mr H.J. Younger of Ashfield, Grange Loan, Edinburgh, for £84,750", although the actual price paid was £110,237. By 19 October Younger was in residence. The new proprietor felt that the picture gallery "did not improve Benmore Mansion" and decided that "the concrete edifice", which "cost between £7000 and £8000, should be broken down". In March 1890 the Paisley firm of James Boyd and Sons, hothouse builders, were "engaged for nearly a fortnight removing the iron work and glass roof". The demolition was completed in July at a cost of £300. Two thousand tons of material were removed and, according to a report in the *Oban Times*, "great care had to be observed in the demolition of the west gable, which was only separated from the house by some 12 feet, and towered 30 feet above the mansion".

During this turbulent period Duncan paid off debts and continued to trade. In 1889 he still held the post of Chairman of the Sugar Refiners' Committee and in the same year was elected Vice President of the Society for Chemical Industry, a position he kept until 1892. Although he could no longer refine sugar on the scale he had in the past, he retained his offices in 9 Mincing Lane, and in 1890 began refining again at Rawcliffe in Yorkshire, where he also lived.

In 1893 Duncan ended his Yorkshire venture and retired from business. For the next 12 years he spent his summers in Scotland and his winters at San Remo in northern Italy. Like other men of his generation, he took a residence on the south east coast of England, moving to a modest house at 52 Shakespeare Street in Hove some time after 1897. He kept two small pictures from his former collection – *Thomas de Quincey* and *Sir Walter Scott* by Sir John Watson Gordon. Another work that meant a great deal to Duncan was Brodie's sculpture of Livingstone. At some point he gave it to his sister Mary, and she displayed it in the hall of Strone House. We can only speculate as to why Duncan held on to these three works but, in view of what Duncan had endured, Scott and De Quincey perhaps reminded Duncan of the instability of worldly wealth, since both had failed to hold on to

▼ Duncan's gravestone situated on the hill behind St Andrews United Free Church, Kilmun. Photo: Andrew M. Watson.

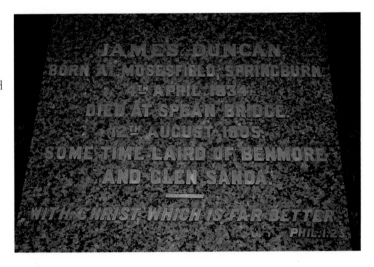

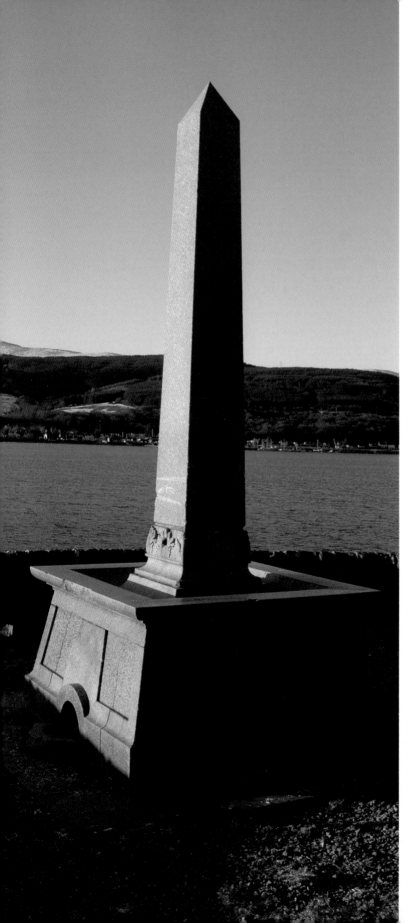

their capital and had had to extricate themselves from debt. Livingstone, symbolic of Christian freedom (the shackles at Livingstone's feet refer to the abolition of slavery), was perhaps a further source of inspiration.

In 1895 Duncan's remaining 136 pictures were auctioned at Christie's. Although not as important as the earlier sales, this one attracted the attention of *The Times*, which concluded that *The Triumph of Ariadne* was the key picture. A year before the last of Duncan's pictures were sold, the collections of many of his Glasgow contemporaries were still being celebrated in leading art periodicals. In 1894 the *Art Journal* reviewed the collection of James Donald; the *Magazine of Art* featured James Reid's collection: its author was the Glasgow writer Robert Walker who, as former Secretary of the Royal Glasgow Institute of Fine Arts during Duncan's time as Vice President, would have been especially aware of the poignancy and irony of Duncan's omission from his series of articles on west-coast collectors. Only six years earlier, in his role as Acting Secretary of the Fine Arts Section for the 1888 Glasgow International Exhibition, he had been unable to secure any of Duncan's masterpieces. By featuring neither in the greatest exhibition yet to have taken place in Glasgow nor in contemporary accounts of west-coast collectors, Duncan was never accorded his rightful place as the greatest living and most esteemed collector of modern European art in Glasgow.

Duncan wanted his collection and estate to be remembered by posterity.

According to Curwen, the closure of his refinery in Clyde Wharf and the sale of his Benmore estate caused him "tragic distress", especially as there was "no doubt that Mr Duncan, in his period of prosperity, meant to leave his estates [including the gallery] on the Clyde as public recreation grounds". Two years after the last of Duncan's pictures were auctioned his fellow sugar magnate, Henry Tate, completed his gallery at Millbank, bequeathing to the nation his sixty-five pictures. The prospect of the Benmore picture gallery becoming a national treasure of comparable international significance had been lost forever.

On 12 August 1905 Duncan died of a heart attack while visiting friends at Spean Bridge in Scotland. His remains were removed by steamer on 16 August and interred in Kilmun cemetery the following day. The Revs D. McKerchar and A. W. Mackinlay led the service at the United Free Church overlooking Holy Loch. Among the mourners were Duncan's nephew, John Moubray; Robert Binnie, ex-provost of Gourock; Henry Younger; Charles Westlands of the Glasgow Abstainers' Union; and a "number of gentlemen connected with the Greenock sugar trade". Duncan was buried on the hill behind the church under a plain red granite gravestone.

Tributes were paid in the *Glasgow Herald* and the *Dunoon Observer and Argyllshire Standard* but, surprisingly, no leading London newspaper featured his obituary. Even *The Times* did not honour one of the most successful men of industry to have worked in London and who had contributed

numerous important articles to its own columns in the 1870s and 1880s. The most significant obituary – one that included the only known photograph of Duncan – was published in an obscure journal not known to the general public. Curwen wrote this account (with additional material from Boyd) in the Congregationalist *Mansfield House Magazine*, published by the Mansfield House University Settlement, founded in 1889 by students of Mansfield College, Oxford to provide opportunities and welfare services for the poor in London's East End. Its mission was to oppose "all evil, selfishness, injustice, vice, disease, starvation, ignorance, ugliness and squalor" in the "spirit of Jesus Christ". Throughout his life Duncan upheld these values in their

◀ Granite obelisk memorial to James Duncan, Holy Loch, Kilmun, Argyllshire. Photo: Andrew M. Watson.

▼ Photograph of James Duncan, c. 1900–1905. Image taken from *Mansfield House Magazine*, 1905. Courtesy of Mansfield College, Oxford.

true spirit, committing himself to the needy without drawing publicity to his actions. It is fitting that Duncan was given his most proper tribute by an organisation that built on the good work he had initiated in London's poorest quarter some 30 years earlier.

Following Duncan's death, funds were raised to commemorate him. According to the *Dunoon Herald*, Cluckie and a number of the Laird's friends "intended placing a suitable memorial in the shape of a fountain on the shores of holy loch". The carving of the granite obelisk was given to Macdonald & Co., Aberdeen Granite Works, Glasgow, and the Glaswegian sculptor Archibald Macfarlane Shannan made an oval bronze bas relief of Duncan, representing the sitter in middle age. The obelisk was formally dedicated on 6 October 1906, during which a vote of thanks was given to Henry Younger, "who had shown great interest in the erection of the fountain". Cluckie spoke of Duncan as a "generous-hearted and good man, whose leading trait was humility". Robert Clark of Dunoon, another of Duncan's friends, remarked that, "one day, years after he had lost his fortune, whilst walking together" Duncan had said to him, "Money is a power but not everything. What I regret the most is that I can't give so much away." In all his obituaries, it was Duncan's philanthropic work that was highlighted as the feature of his life and character by which he would be "chiefly remembered". The bronze panel originally attached to the base of the obelisk, which has recently been replaced, read:

"Erected by public subscription in memory of James Duncan (a former laird of Benmore), sugar refiner, Greenock and London, who by his chemical research and enterprise revolutionised the sugar-refining industry of Great Britain, and by his Christian character and benevolence won the gratitude and esteem of his fellow men. Born Springburn, 4 April, 1834; died at Spean Bridge, 12th August, 1905".

No visitor to this memorial was reminded of Duncan's achievements as a collector.

▼ Benmore House today, Benmore Botanic Garden. Photo: Andrew M. Watson.

Shannan's study of Duncan does not fully reveal the character of the sitter. The photograph of Duncan taken in the 1870s, however, shows the driven and pioneering spirit, who conceived and realised all his ventures on a grand scale. Duncan's genius in chemistry and in commerce revolutionised the sugar industry in Britain, his vast enterprise being the largest in London; his concern for the poor was expressed first in revitalising the poorest areas of London and subsequently in supporting charitable institutions throughout Britain, contributing annually vast sums of his own money; his knowledge of arboriculture and agriculture led him to undertake the huge challenge of cultivating Benmore garden and estate: over six million trees that we enjoy today are testament to his dedication; and his passion for art was reflected in a huge collection of international standing, with key pictures that hang today in the world's most important museums and galleries. Had it stayed intact, the Duncan collection would be as familiar as those named after Burrell or Wallace.

Few visitors to the Louvre, the Metropolitan Museum in New York or the Upper Belvedere in Vienna will be aware of the original gallery in which *Sardanapalus*, *The Bay of Naples* and *The Triumph of Ariadne* once hung. It was an extraordinary building, larger than the National Gallery in Edinburgh, the interior of which must have provided an experience similar to one of the *grandes salles* of the Louvre. Its situation in one of the most beautiful locations in Scotland made it all the more extraordinary. Today,

the monogrammed golden gates at Benmore are the only reminder there of Duncan's artistic ventures.

Duncan's reserve and deeply held Christian values on the one hand, and his ability to generate enormous wealth and spend it on audacious personal projects on the other, must have troubled him. Like many art collectors, Duncan realised that pictures are not just symbols of ostentatious wealth but bring enduring pleasure, transcending any monetary values attached to them. In this way Duncan's collecting was an act of faith. His failure to leave Benmore and its picture gallery to the nation caused Duncan inordinate distress. Witnessing the gradual erosion of his wealth in the knowledge that he must abandon his Benmore project almost as soon as it had been completed, Duncan emerges as an archetypal tragic hero.

Although his achievements as a collector were not fully recognised in his lifetime, in some ways it is Duncan's pictures which tell us most about him. In the National Gallery of Scotland's 2008 Edinburgh International Festival exhibition *Impressionism and Scotland* Duncan's Renoir – *The Bay of Naples* – took centre stage as the first Impressionist picture to be acquired by a Scottish collector. It was fitting that his Renoir, emblematic of Duncan's good taste, was shown in Edinburgh, the city in which his French pictures should have been celebrated at the 1886 International Exhibition. Duncan can now be accorded his rightful place in the history of Scottish collecting, as one of the most prescient entrepreneurs of his generation and as a truly enlightened Victorian.

Bibliography

All extracts from sources in Glasgow University Library appear Courtesy of University of Glasgow Library, Department of Special Collections and those from materials in the Mitchell Library, Courtesy of the Mitchell Library, Glasgow City Council.

Archival Sources

Biographical Database of the British Chemical Community, 1880–1970, Open University [online database]. http://www.open.ac.uk/ou5/Arts/chemists

Book of Particulars, Plan, and Photograph of the Magnificent Highland Domain of Benmore, Bernice, & Kilmun, in Argyllshire, Messrs. J Watson Lyall & Co. Land Agents, 15 Pall Mall, London, Messrs. Blair and Finlay, W. S., 27 St Andrew Square, Edinburgh 1889. Records of William Younger & Co Ltd, Brewers, Edinburgh, Scotland, Scottish Brewing Archive at Glasgow University Archive Services and Scottish & Newcastle UK. Younger Brewing Archive, Glasgow University Archives, GB1127 WY13/7/6.

Confirmation of James Duncan, Scottish Record Office, Edinburgh, SC70/5/93.

Durand-Ruel Stock Books, Archives Durand-Ruel, Paris.

Edinburgh International Exhibition: Volume of Circulars, 1885–86, Edinburgh City Archives, ACC 423.

'Fragmenta Prosaica Motherwell', Glasgow University Archives, MS Robertson 9.

Glasgow Abstainers' Union Minute Book, Special Collections, Mitchell Library, Glasgow, TD432/1/3.

Glasgow International Exhibition, Letter Book no. 2, 1888, Special Collections, Mitchell Library, Glasgow.

Goupil & Cie/Boussod, Valadon & Cie Stock Books, Getty Research Centre [online database]. <http://www.getty.edu/research/conducting_research/provenance_index/goupil_cie/index.htm

Inventory of James Duncan, died 1905, Scottish Record Office, Edinburgh, SC70/1/461.

Register of Sasines for Argyllshire and Bute, Argyll and Bute Archives, Lochgilphead.

Register of Sasines for Glasgow, Glasgow City Archives, Special Collections, Mitchell Library, Glasgow.

Royal Glasgow Institute of Fine Arts, Minute Books, 1875–1883; 1883–1891, Special Collections, Mitchell Library, Glasgow.

Royal Glasgow Institute of Fine Arts, Press Cuttings Book, 1876–1887, Special Collections, Mitchell Library, Glasgow.

Royal Glasgow Institute of Fine Arts, Sales Book, 1870–1882, Special Collections, Mitchell Library, Glasgow.

'Scotland's People', Official Government Source of Genealogical Data for Scotland [online]. <http://www.scotlandspeople.gov.uk/>

William Mossman Job Book, 1835–9, Special Collections, Mitchell Library, Glasgow, GLASM 1986.191/6.

Books and Articles

Ackerman, Gerald M., *The Life and Works of Jean-Léon Gérôme with a Catalogue Raisonné* (London, 1986).

Anon., 'The Spy System: or 'Tis Thirteen Years Since', *Tait's Edinburgh Magazine*, 14 (1833), 198–222.

Anon., 'The Great Exhibition in Dublin', *Art Journal*, 5 (1853), 117.

Anon., 'Dinner in honour of Mr James Duncan Esq. of Benmore', *Dunoon Observer and Argyllshire Standard* (15 June 1872).

Anon., 'Art in Continental States', *Art Journal*, 12 (1873) 137.

Anon., 'Glasgow Fine Art Exhibition', *The Scotsman* (2 February 1875), 5.

Anon., 'The Glasgow Art Institute', *Glasgow Herald* (31 January 1876), 4.

Anon., 'Glasgow Fine Art Institute', *The Scotsman* (31 January 1876), 3.

Anon., 'The British Association Meeting at Glasgow', *The Scotsman* (1 September 1876), 3.

Anon., 'The Paris Exhibition', *The Scotsman* (10 June 1878), 5.

Anon., 'Glasgow Fine Art Institute', *The Scotsman* (2 February 1880), 5.

Anon., 'The Black and White and Bough and Chalmers Exhibition', *North British Daily Mail* (3 August 1880), 2.

Anon., *North British Daily Mail* (3 August 1880), 2.

Anon., 'The Benmore Picture Gallery', *Dunoon Observer and Argyllshire Standard* (20 July 1882).

Anon., 'The Picture Gallery at Benmore', *Dunoon Observer and Argyllshire Standard* (2 September 1882).

Anon., 'The Hamilton Palace Dispersion', *The Christian Leader* (1882), 473.

Anon., 'Mr Spurgeon's Argyllshire Host', *The Christian Leader* (1882), 547.

Anon., 'Anecdote of Mr Spurgeon at Benmore', *The Christian Leader* (1883), 483.

Anon., 'The Proposed International Forestry Exhibition in Edinburgh', *The Scotsman* (26 September 1883), 6.

Anon., 'Institute of Fine Arts', *Glasgow Herald* (30 January 1885), 9.

Anon., 'Bencan of Dunmore', *Fairplay*, 2/25 (1886), 533–534.

Anon., 'Note – "Bencan of Dunmore"', *Fairplay*, 2/27 (1886), 65.

Anon., 'Sale of the Benmore Art Collection', *Dunoon Observer and Argyllshire Standard* (27 April 1889).

Anon., 'Art Sales', *The Times* (11 February 1895), 10.

Anon., 'Sales of the Past Year: Pictures and Drawings', *The Times* (4 January 1896), 4.

Anon., 'Prominent Sugar Refiner', *Glasgow Herald* (15 August 1905), 9.

Anon., 'Death of Mr James Duncan, late of Benmore', *Dunoon Observer and Argyllshire Standard* (19 August 1905).

Anon., 'The Donald Bequest', *Art Journal*, 46 (1905), 190.

Anon., 'James Duncan Memorial Fountain', *Dunoon Herald* (8 October 1906).

Anon., *The Story of the Glasgow Abstainers' Union, 1854–1914* (Glasgow, 1914).

Anon., 'The Burdett-Coutts Collection: Souvenirs of Famous Men', *The Times* (6 March 1922), 22.

Anon., 'Burdett-Coutts Pictures: first Day's Sale at Christie's', *The Times* (5 May 1922), 13.

Anon., *A Reputation for Excellence: a History of the Glasgow Printing Industry* (Edinburgh, 1994).

Bailey, Colin B. et al., *Renoir Landscapes: 1865–1883*, exh. cat., National Gallery, London (London, 2007).

Billcliffe, Roger, *The Royal Glasgow Institute of the Fine Arts 1861: a Dictionary of Exhibitors at the Annual Exhibitions*, 4 vols (Glasgow, 1990).

Catalogue of the Glasgow Institute of Fine Arts: Tenth Exhibition of Works of Modern Artists (Glasgow, 1871).

Catalogue officiel de l'Exposition Universelle Internationale de 1878, à Paris (Paris, 1878).

C. H. Spurgeon Autobiography, Volume 2: The Full Harvest, 1860–1892, eds. Susannah Spurgeon and Joseph Harrold (1897–1900; rev. edn, Avon, 1995).

Clerk, Duncan, *Transactions of the Highland and Agricultural Society of Scotland: on the Agriculture of the County of Argyll* (Edinburgh and London, 1878).

Colvin, Howard, *Dictionary of British Architects 1600–1840* (London, 1978).

Cooper, Douglas, *The Courtauld Collection: a Catalogue and Introduction* (London, 1954).

Curwen, James Spencer, *Old Plaistow* (London, 1892).

Curwen, James Spencer, 'The Late Mr James Duncan', *The International Sugar Journal*, 7 (1905), 563–564.

Curwen, James Spencer, 'The Late Mr James Duncan', *Mansfield House Magazine*, 12/11 (1905), 171–177.

Duncan, James:

'Money Market and City Intelligence', *The Times* (12 February 1868), 7.

'Beet Sugar', *The Times* (10 February 1871), 11.

'The Sugar Question', *The Times* (4 November 1879), 4.

'Money Market and City Intelligence', *The Times* (12 May 1880), 9.

'Money Market and City Intelligence', *The Times* (13 May 1880), 7.

'Our Agricultural Prospects', *The Times* (15 May 1880), 8.

'Agricultural Prospects', *The Times* (20 May 1880), 8.

'The French Sugar Bounties', *The Times* (23 June 1880), 10.

'Railway Rates', *The Times* (22 June 1882), 4.

'The Sugar Bounties', *The Times* (23 June 1884), 6.

'The West India Colonies', *The Times* (14 August 1884), 4.

'The Sugar Bounties and the West India Colonies', *The Times* (18 August 1884), 3.

'The New Railway Bills', *The Times* (6 February 1885), 10.

'The Board of Trade Report on the Sugar Bounties', *The Times* (19 June 1889), 6.

[Duncan, James] *Catalogue of Ancient and Modern Pictures and Water-colour Drawings, including a small Collection, the Property of a Gentleman*, Christie, Manson and Woods (London, 16 July 1887).

Catalogue de tableaux modernes composant la collection de M. Duncan (De Londres), Hôtel Drouot (Paris, 15 April 1889).

Catalogue of Ancient and Modern Pictures, Property of a Gentleman, Foster (London, 19 June 1889).

Catalogue of Ancient and Modern Pictures and Sculpture, being the remaining Portion of the Collection of James Duncan Esq. of Benmore, Christie, Manson and Woods (London, 9 February 1895).

Catalogue of Old English and Foreign Silver and Silver-gilt Plates, Silver and Plated Articles from the Collection of James Duncan Esq. (formerly of Benmore) Christie, Manson and Woods (London, 28 February 1895).

Catalogue of Highly Important Pictures of the early English School and a few Works by Old Masters, Christie, Manson and Woods (London, 26 May 1906).

[Durand-Ruel] *Exposition rétrospective de tableaux et dessins des maîtres modernes* (Paris, 1878).

Catalogue de l'Exposition des œuvres de P.-A. Renoir (Paris, 1883).

[Ellis, Wynn] *Catalogue of the second Portion of the Wynn Ellis Collection: Pictures by Dutch and Flemish Masters*, Christie, Manson and Woods (London, 27 May 1876).

Fernier, Robert, *La vie et l'œuvre de Gustave Courbet* (Geneva, 1977).

Feuchtwanger, E. J., *Democracy and Empire: Britain 1865–1918* (Suffolk, 1985).

Fletcher, Pamela, 'Creating the French Gallery: Ernest Gambart and the Rise of the Commercial Art Gallery in Mid-Victorian London', *Nineteenth-Century Art Worldwide* [online journal], 6/1 (2007). <http://www.19thc-artworldwide.org/>

Fowle, Frances, *Impressionism and Scotland*, exh. cat., National Gallery of Scotland, Edinburgh (Edinburgh, 2008).

Fowle, Frances, 'West of Scotland Collectors of Nineteenth-Century French Art', in Vivien Hamilton, ed., *Millet to Matisse: Nineteenth- and Twentieth-Century French Painting from Kelvingrove Art Gallery, Glasgow*, exh. cat., Kelvingrove Art Gallery, Glasgow (New Haven and London, 2002).

Fowler, John, *Recollections of Old Country Life* (London, 1894).

Frodl, Gerbert., *Hans Makart: Monographie und Werkverzeichnis* (Salzburg, 1974).

Gibby, Mary, *The Benmore Fernery: celebrating the World of Ferns* (Edinburgh, 2009).

Glasgow Contemporaries (Glasgow, 1931).

Gould, Cecil, 'An Early Buyer of French Impressionists in England', *Burlington Magazine*, 108 (March 1966), 141–142.

Graves, Algernon, *Art Sales from early in the Eighteenth Century to early in the Twentieth Century* (London 1918–1921).

Green, Nicholas, 'Dealing in Temperaments: Economic Transformation of the Artistic Field in France during the Second Half of the Nineteenth Century', *Art History*, 10/1 (1987), 59–78.

[Hamilton] *Catalogue of the Collection of Pictures, Works of Art, and Decorative Objects, the Property of His Grace The Duke of Hamilton, K.T.*, Christie, Manson and Woods (London, 17, 19 June 1882).

Heaton, M. M., 'Society of French Artists', *The Academy*, 4/71 (1873), 168–169.

Hellebranth, Robert, *Charles-François Daubigny, 1817–1878* (Morges, 1976).

Herring, Sarah, 'The National Gallery and the Collecting of Barbizon Paintings', *Journal of the History of Collections*, 13/1 (2001), 77–89.

Hutcheson, John, *Notes on the Sugar Industry of the U.K.* (Greenock, 1901).

Illustrirter Katalog der internationalen Kunstausstellung im Königl. Glaspalaste in München 1883 (Munich, 1883).

Ingamells, John, ed., *The Hertford Mawson Letters: The 4th Marquess of Hertford to His Agent Samuel Mawson* (London, 1981).

In Memoriam 1895: James Reid of 10 Woodside Terrace Glasgow and of Auchterarder Perthshire (Glasgow, 1895).

International Exhibition of Industry, Science & Art, Edinburgh, 1886: Catalogue of the Pictures and Works of Art (Edinburgh, 1886).

Janson, H. W., *Catalogues of the Paris Salon: 1673–1881*, 60 vols (New York and London, 1977).

Johnson, Lee, *The Paintings of Eugène Delacroix: A Critical Catalogue*, 6 vols (Oxford, 1981–9).

Korn, Madeleine, 'Exhibitions of Modern French Art and Their Influence on Collectors in Britain, 1870–1918: The Davies Sisters in Context', *Journal of the History of Collections*, 16/2 (2004), 207–8.

Lannoy, Isabelle de, *Jean-Jacques Henner: Catalogue raisonné* (Paris, 2008).

Lewis, Frank, *Essex and Sugar: Historic and other Connections* (London, 1976).

López-Rey, José, *Velázquez: a Catalogue Raisonné of his Oeuvre* (London, 1963).

Maas, Jeremy, *Gambart: Prince of the Victorian Art World* (London, 1975).

Mackenzie, Peter, *Reminiscences of Glasgow and the West of Scotland* (Glasgow, 1875).

Mainardi, Patricia, *Art and Politics of the Second Empire: The Universal Expositions of 1855 and 1867* (New Haven and London, 1987).

Martineau, George, *Sugar Cane and Beet: an Object Lesson* (London, n.d.).

Martineau, George, in James Spencer Curwen, 'The Late Mr James Duncan', *The International Sugar Journal*, 7 (1905), 564.

Martin's Guide to Dunoon, Innellan, Kirn, Hunter's Quay, Sandbank, Kilmun, Strone and Blairmore with Map and Illustrations (Dunoon, 1881).

Matteucci, Giuliano, *Lega: l'opera completa*, 2 vols (Florence, 1987).

Mavor, Irene, 'Glasgow, 1860–1914: Portrait of a City', in Vivien Hamilton, ed., *Millet to Matisse: Nineteenth- and Twentieth-Century French Painting from Kelvingrove Art Gallery, Glasgow*, Kelvingrove Art Gallery, Glasgow (New Haven and London, 2002).

McConkey, Kenneth, '"Silver Twilights" and "Rose Pink Dawns": British Collectors and Critics of Corot at the turn of the century', in *J. B. Corot*, exh. cat. (Tokyo, Osaka, Yokohama, 1989).

Memorial Catalogue of the French and Dutch Loan Collection, Edinburgh International Exhibition 1886 (Edinburgh, 1888).

Ménard, René, 'Pierre Billet', *The Portfolio*, 6 (1875), 19–20.

Milner, John, *The Studios of Paris: the Capital of Art in the late Nineteenth Century* (New Haven and London, 1988).

Morris, Edward, *French Art in Nineteenth-Century Britain* (New Haven and London, 2005).

Niccol, Robert, *Essay on Sugar and General Treatise on Sugar Refining* (Greenock, 1864).

Official Catalogue of the Glasgow Fine Art Loan Exhibition in aid of the Funds of the Royal Infirmary, held in the Corporation Galleries, Sauchiehall Street: with descriptive and biographical Notes by a Member of the Acting Committee, May, June, July, 1878 (Glasgow, 1878).

Official Catalogue of the Great Industrial Exhibition; (in connection with the Royal Dublin Society), 1853 (Dublin, 1853).

Ormond, Richard, *Sir Edwin Landseer*, exh. cat., Tate Gallery, London (London, 1981).

Pickvance, Ronald, *A Man of Influence: Alex Reid (1854–1928)*, exh. cat., Scottish Arts Council Gallery, Edinburgh (Edinburgh, 1967).

Pickvance, Ronald, 'Degas's Dancers: 1872–6', *Burlington Magazine*, 105 (June 1963), 257.

Pickvance, Ronald, 'Henry Hill: An Untypical Victorian Collector', *Apollo*, 76 (1962), 789–791.

Pictures from the Collection of James Reid of Auchterarder (n.p., 1894).

Pillet, Ch., *Exposition Meissonier, 24 Mai-24 Juillet 1884* (Paris, 1884).

Randall, Lilian, *The Diary of George A. Lucas: an American Art Agent in Paris, 1857–1909*, 2 vols (Princeton, 1979).

Ravenel, Jean, 'Vente de la collection de M. Th. Edwards', *Revue internationale de l'art et de la curiosité*, 3 (1870), 105–116; 232–238.

Read, Benedict, *Victorian Sculpture* (London, 1982).

Redford, George, *Art Sales*, 2 vols (London, 1888).

Rewald, John, 'Theo van Gogh, Goupil, and the Impressionists', *Gazette des Beaux-Arts*, 81 (January 1973), 1–108.

Roosevelt, Blanche, *Life and Reminiscences of Gustave Doré, compiled from Material supplied by Doré's Relations and Friends, and from personal recollection* (London, 1885).

Russell, Francis, *Portraits of Sir Walter Scott: a Study of Romantic Portraiture* (London, 1987).

Schulman, Michel, *Théodore Rousseau (1812–1867): Catalogue raisonné de l'œuvre peint* (Paris, 1999).

Soullié, Louis, *Les grands peintres aux ventes publiques II: peintures, aquarelles, pastels, dessins de Jean-François Millet relevés dans les catalogues de ventes de 1849–1900* (Paris, 1900).

Sproule, John, ed., *The Irish Industrial Exhibition of 1853: a detailed Catalogue of its Contents* (Dublin, 1854).

Stalker, Donald, *Transactions of the Highland and Agricultural Society of Scotland: 'Plantations of the Estates of Benmore and Kilmun, Argyllshire'* (Edinburgh and London, 1880).

Sixth Annual Report of the Glasgow Emancipation Society with a List of Subscribers (Glasgow, 1840).

Stevenson, R. A. M., 'A Representative Scottish Collection', *Art Journal*, 33 (1894), 257–61.

Thomson, David Croal, *The Barbizon School* (London, 1891).

Thomson, Duncan, *Raeburn: The Art of Sir Henry Raeburn 1756–1823*, exh. cat., Scottish National Portrait Gallery, Edinburgh (Edinburgh, 1997).

Thomson, Richard, 'Theo Van Gogh: an honest Broker', in Chris Stolwijk and Richard Thomson, *Theo Van Gogh 1857–1891: Art Dealer, Collector and Brother of Vincent*, exh. cat., Van Gogh Museum, Amsterdam (Zwolle, 1999).

Venturi, Lionello, *Les archives de l'Impressionnisme*, 2 vols (Paris, 1939).

Walker, Frank, ed., *The Buildings of Scotland: Argyll and Bute* (London, 2000).

Walker, Robert, 'Private Picture Collections in Glasgow and West of Scotland: I – Mr James Reid's Collection', *Magazine of Art*, 17 (1894), 153–159.

Watson, Andrew, 'Constantine Ionides and his Collection of Nineteenth-century French Art', *Journal of the Scottish Society for Art History*, 3 (1998), 25–31.

Watson, Andrew, 'James Duncan of Benmore, the First Owner of Renoir's Bay of Naples (Morning)', *Metropolitan Museum Journal*, 43 (2008), 195–200.

Watson, Andrew, 'James Duncan 1834-1905', in Frances Fowle, *Impressionism and Scotland*, exh. cat., National Gallery, Edinburgh (Edinburgh, 2008), 129.

Watson, Andrew, 'James Duncan: a Remarkable Victorian Collector', *Journal of the Scottish Society for Art History*, 14 (2009), 40–50.

Whiteley, Linda, 'Accounting for Tastes', *Oxford Art Journal*, 2 (1979), 25–28.

Whiteley, Linda, 'L'école de Barbizon et les Collectionneurs Britanniques avant 1918', in *L'école de Barbizon: Peindre en plein air avant l'impressionnisme*, exh. cat. (Paris, 2002).

Whyte, Hamish, 'Motherwell, William (1797–1835)', *Oxford Dictionary of National Biography [online]*, (Oxford University Press, 2004). <http://www.oxforddnb.com/index.jsp>

Younger, David, *Country House Life in the Highlands: the Younger Family at Benmore 1889–1929* (Edinburgh, n.d.).

Zola, Émile, 'L'École française de Peinture à l'exposition de 1878', in F. W. S. Hemmings and Robert J. Niess, eds, *Émile Zola: Salons* (Geneva and Paris, 1959).

Appendix I

CHECKLIST OF JAMES DUNCAN'S PICTURES

This checklist comprises works mentioned in 19th-century newspapers, auction catalogues, sales books, exhibition catalogues and dealers' ledgers. It is not complete, as many of Duncan's pictures were sold privately. Works produced between 1700 and 1900 are given first, followed by pictures painted before 1700. This is because the mainstay of his collection was the 19th-century component, containing Duncan's most significant works, all of which are highlighted in the text. In both sections painters are arranged alphabetically by nationality. Unless a picture is now known by a different name, the original titles are given. If an artist's nationality is uncertain, he is listed under a separate heading. An asterisk indicates attributions that are beyond doubt. In all other cases, the names of artists and pictures are listed as cited in the contemporary sources.

When known, the dimensions, dates and locations of pictures are included. Measurements are given in centimetres, height before width.

All works are in oils unless otherwise stated.

1700–1900

American

G. L. Brown
The Falls of Niagara

Austrian

E. de Blaas
A Carnival Scene, Venice (1873)

Dollinger
Cattle

F. Gauerman
Bears in a Landscape

T. Gauerman
A Cow in a Stall
A Landscape in Tyrol with Herdsmen and Cattle
A Mountainous Landscape with Peasants and Cattle (1869)
A Mountain Scene with Deer (1888)
A Ravine with Bears
An Ox
Chamois Hunting (1851)

R. Huber
Landscape with Cattle and Peasant Children (1872)

Jettel
Dutch Landscape, 35 × 63 (1874)

Hans Makart
Portrait
* *The Triumph of Ariadne*, 476 × 784 (1874, Upper Belvedere, Vienna)

Rumpler
Boy with Thorn
The Little Gamblers

A. Schaeffer
A Woody Landscape with Peasants and Felled Trees
Forest Scene in Bohemia

A. Schonn
Landing Fish at Venice

Belgian

De Noter
An Interior with a Lady and Still Life

Van Schendel
Market Scene – Candlelight

Alfred Stevens
La mendicité tolérée, 128 × 98

Eugène Verboeckhoven
The Sheepfold, 52 × 65 (1873)

Czech

G. Max
A Lady with Flowers

Dutch

David Bless
Gentleman Playing with his Children, 30 × 24 (1871)

Josef Israels
The Fisherman

W. G. J. Nuijen
A Dutch Mill with Figures

Henriette Ronner
The Donkey's Story

W. Verschuur
Interior of a Stable with a Grey Horse

English

Andrews
Napoleon in Battle

T. Barker
A Woody Landscape with Figures

P. H. Calderon
Sylvia

Crome
A Woody Landscape
The Edge of a Wood with Figures

Ewbank
A Coast Scene with Boats and Figures

Gair
Portrait of a Gentleman
Portrait of Dr Stenhouse

D. Gardner
Portraits of the Misses Gunning

T. Good
A Sea Piece

T. Hart
A View near Amalfi
(drawing or watercolour) (1871)
Cadgwith Cove, Cornwall
(drawing or watercolour)
Cornish Coast Scenes – a pair
(drawings or watercolours)
(Two ditto) (drawings or watercolours)
Lake and River Scene
(drawing or watercolour)
On the Cornish Coast
(drawing or watercolour) (1860)

Sir Edwin Landseer

**Sir Walter Scott in the Rhymer's Glen*, 152.4 × 121.9 (1833, Private Collection)

E. J. Poynter

A Philosopher

J. B. Pyne

A Coast Scene

T. Webster

The Cut Finger

Williams

A Landscape with Animals

French

Camille Bernier

Sabotiers dans le bois de Quimerc'h (Finistère), 194 × 296 (1877)

Pierre Billet

Bûcheronne sous bois, 80 × 58 (1873)
French Peasants
**Ramasseuses de bois*, 113 × 148 (1874, Private Collection)

Rosa Bonheur

Cattle Shed
Highland Bull
Sheep, 42.5 × 32

Boucher

The Bird's Nest

Eugène Boudin

Soleil couchant

William Bouguereau

**La nuit*, 208 × 107 (1883, Hillwood Museum, Washington DC)

Canon

Two Portraits

Carolus-Duran

Portrait of Gustave Doré, 193 × 128 (1877)
Tête de femme, 21 × 15

Chaplin

Jeune femme à sa toilette, 103 × 73
Landscape (Evening)

Camille Corot

**La toilette*, 150 × 89.5 (1859, Private Collection, Paris)
**The Environs of Paris,* 34.3 × 51.4 (1860s, The Metropolitan Museum of Art, New York)
**Le Passage du gué*, 99 × 135 (Musée des Beaux-Arts de Rennes)

P. A. Cot

The Magdalen, 105 × 150 (1875)

Gustave Courbet

Forêt et cascade, 79.5 × 63.5
**La bergère*, 129 × 199 (1866)

Charles-François Daubigny

**The Banks of the Oise*, 37.5 × 67 (1863, The Metropolitan Museum of Art, New York)
Village with Bridge, 37 × 66

Karl-Pierre Daubigny

Landscape

Eugène Delacroix

**Interior of a Dominican Convent in Madrid*, 130.2 × 161.9 (1831, Philadelphia Museum of Art)
**The Death of Sardanapalus*, 392 × 496 (1827, Musée du Louvre)

P. Delaroche

Charity

Diaz

A Female Study
Chêne (Grands personnages), 173 × 205
Petits pêcheurs, 58.25 × 72
Venus portant Cupidon, 53 × 30.25

Gustave Doré

A Midsummer Night's Dream, 128 × 193 (1873)
An Alpine Landscape (1873)
L'Aurore dans les Alpes, 130 × 192 (1878)
Titania, 274 × 198

Duez

Une Parisienne, 188 × 80 (1874)

Jules Dupré

Ferme et vaches dans l'eau, 32 × 23.75
Landscape

E. Fichel

Cuvier écrivant l'histoire des poissons, 40 × 32 (1873)
The Connoisseur
The Musician, 40 × 32 (1874)

J. Gelibert

Highland Game (1875)
Un Relais de chiens en forêt, 64 × 94 (1874)

J.-L. Gérôme

Two Greyhounds at a Fountain, 32 × 40

F. Girard

Les financés
The Marriage

Greuze

Head of a Boy

Jean-Jacques Henner

**Églogue*, 160 × 300 (1879, Musée du Petit Palais, Paris)

Lecomte du Noüy

The Opium Smoker, 38 × 64 (1874)

Jules Lefèbvre

**Diana Surprised*, 275 × 370 (1879, Museo de Bellas Artes, Buenos Aires)

E. van Marcke

Cattle under the Trees, 58 × 91
The Snake in the Grass

Ernest Meissonier

The Captain, 36 × 24 (1865)
The Standard Bearer, 16.5 × 27.5

J. Mélin

Chiens de chasse, 48 × 60 (1869)
Chiens de chasse au repos, 109 × 146 (1876)
Dogs
Hounds

Luc-Olivier Merson

Bella Matribus Detesta, 335 × 411 (1874)

F. Mesgrigny

A Lake Scene
Bords de la Marne, 58 × 98
Bords de rivière, 58 × 98
Landscape
On the Banks of the Seine

Jean-François Millet
Boat at Sea, 32 × 41 (1871)
**The Sheepshearers*, 40.8 × 32.5 (1857–1861,
The Art Institute of Chicago)

Morlon
La rentrée du bateau de sauvetage, 198 × 300

Auguste Renoir
**The Bay of Naples (Morning)*, 59.7 × 81.3
(1881, The Metropolitan Museum
of Art, New York)

Ph. Rousseau
Still Life with Birds (1863)

Théodore Rousseau
Allée sous bois, 19.25 × 23.5
**Evening*, 200 × 136 (1865)
**Le Mont Chauvet, Forêt de Fontainebleau*,
46 × 65 (1845–1850)
**Morning*, 200 × 136 (1865)

Henri Schlesinger
The Coffee Girl

Constant Troyon
Cattle Piece
Landscape
Man with White Cow, 49.25 × 69

Veyrassat
Chevaux au puits, 89 × 118 (1875)

Antoine Vollon
**Femme du Pollet, à Dieppe*, 183 × 105
(c. 1876, Gemeentemuseum, The Hague)

German

C. Becker
Portrait of a Lady (1874)
Portrait of Miss Becker
The Toilet

Fritzetag Kaulbach
Portrait of a Lady

W. Kaulbach
Charity (charcoal)

Klein
Horse and Tent
Horses in a Landscape
Lake Scene with Peasant and Horses (1837)
Landscape with Peasant, Wagon and Horses
(1850)

Ludwig Knaus
In Bodily Fear
L'enfant au vin, 78 × 54.5
Portrait of a Lady
**Springtime*, 66 × 50
(1868, Private Collection)

Lenbach
Portrait of Hans Makart

Adolf Menzel
A Street in Paris

Schleich
Man and Sheep

Schreyer
Chantier Bulgare, 55 × 94
Horses

Voltz
Landscape with Cattle (Evening), 39 × 89
Landscape with Cattle (Morning), 39 × 89

Italian

C. Ademollo
An Italian Girl with a Basket of Grapes
(1877)
Garibaldi Reading a Despatch
Lord Napier at Magdala
The Letter
The Rustic Amateur
Woman with Flowers
Youth and Age

G. Chierici
Afternoon at the Monastery

Tito Conti
After Dinner

Detti
La cinquantaine
The Golden Wedding

Silvestro Lega
**The Dying Mazzini (Mazzini morente)*,
74.8 × 98 (1873, Museum of Art,
Rhode Island School of Design)

Mulanelli
A Vestal Virgin (1876)

De Nittis
Avenue Impératrice, Bois de Boulogne,
30 × 41 (1871)

Sorbi
Le Réveil: Roman Woman and Child

Irish

A. Johnson
The Press Gang

Norwegian

Otto Sinding
**Funeral at Lofoten (Winter)*,
289 × 396 (1885, Galleri Lofotens Hus,
Henningsvaer)
Laplanders Saluting the Sun,
289 × 396 (1885)

Russian

Harlamoff
Head of a Girl

Scottish

James Docharty
Head of Loch Eck
Loch Katrine
The Road to Fernhouse, Benmore

M. Gillies
After the Ball: the Proposal

Knox
Loch Lomond from Ben Lomond

P. Nasmyth
A River Scene with Figures and Horses

Sir Henry Raeburn
Duchess of Hamilton
Sir David Brewster
John Rennie
**Sir Walter Scott*, 76.2 × 63.5
(1822, Scottish National Portrait Gallery)

Sir John Watson Gordon
Portrait of Sir Thomas de Quincey,
76.2 × 63.5
**Portrait of Sir Walter Scott*,
76.2 × 63.5 (c. 1831–1835,
Philadelphia Museum of Art)